The Artist's Painting Library
COLOR IN WATERCOLOR

BY WENDON BLAKE/PAINTINGS BY FERDINAND PETRIE

WATSON-GUPTILL PUBLICATIONS/NEW YORK

Published 1982 in the United States by Watson-Guptill Publications,
a division of Billboard Publications, Inc.,
1515 Broadway, New York, N.Y. 10036

Library of Congress Cataloging in Publication Data

Blake, Wendon.
 Color in watercolor.

 (The Artist's painting library)
 Originally published as pt. 2 of: The color
book. 1981.
 1. Water-color painting—Technique. 2. Color
in art. 3. Color guides. I. Petrie, Ferdinand,
1925– . II. Title. III. Series: Blake, Wendon.
Artist's painting library.
ND2422.B5 1982 752 81-21883
ISBN 0-8230-0744-8 AACR2

Manufactured in Japan

7 8 9/90

CONTENTS

Color in Watercolor Painting. Watercolor is unusual among painting mediums in that the color is essentially transparent. A brushstroke of watercolor consists mainly of pure water in which a small amount of color has been dissolved, so you're really painting with tinted water! When that water evaporates from the paper, a microscopic amount of color remains on the white painting surface, which shines through the color like sunlight through stained glass. For this reason, a watercolor painting can have extraordinary luminosity, a kind of inner light that no other painting medium can match. And because of this remarkable combination of transparency and luminosity, watercolor can produce color effects that are so varied and surprising that many artists have devoted their lives to this single medium. For everyone who's fascinated by watercolor, *Color in Watercolor Painting* has a twofold purpose: first it serves as an introduction to the basics of color as it applies specifically to watercolor painting; then it surveys the surprising range of watercolor techniques that artists have developed over the centuries.

Values. Oddly enough, one of the secrets of successful color is learning to think in black-and-white. To observe and paint the colors of nature with the greatest possible accuracy, you must be able to judge the comparative lightness and darkness of those colors. The best way to do this is to imagine that those colors are actually various shades of gray, which are called *values*. The first section of *Color in Watercolor Painting* teaches you how to do this. You'll learn to look at the colors of nature and convert them to values in your mind's eye. You'll find instructions for painting your own value chart in watercolor, which you can keep as a permanent reference. You'll then watch Ferdinand Petrie paint two demonstration watercolors, step-by-step, one in just three values and the other in four.

Color Control. To discover how your tube colors behave in various mixtures, you'll conduct a series of color tests and paint your own color charts in watercolor. You'll also learn how to plan the color schemes of your watercolor paintings so that specific colors look brighter or more subdued, darker or lighter. A series of colorful illustrations will reveal how to use transparent watercolor to create the illusion of perspective, to achieve satisfying color harmony, to render the subtle color changes that take place at different times of day and night, and to enhance your pictorial composition.

Demonstrations. The largest single section of *Color in Watercolor Painting* is devoted to a series of ten step-by-step demonstrations in which Ferdinand Petrie shows you ten different ways to paint a watercolor. He begins with the simple, direct methods that are most widely used by contemporary watercolorists, and then introduces a variety of exciting methods that will be new and refreshing to many contemporary painters, although most of these techniques actually go back to eighteenth-and nineteenth-century masters of the medium. In each demonstration, you'll not only learn a specific watercolor technique, but you'll also see how this technique can produce its own particular color effects.

Ten Watercolor Techniques. Petrie begins by painting a picture with just two colors—a valuable exercise because it strengthens your understanding of values and also teaches you how much color you can actually create with a very limited watercolor palette. Then he paints a picture with the three primaries—red, blue, and yellow—to show you the rich variety of color mixtures you can achieve with just these three basic hues. The next two demonstrations show how the full watercolor palette can be used to paint one picture in subdued colors and another in brighter colors. The artist then demonstrates the classic technique of the British masters: a monochrome underpainting followed by an overpainting in full color. Petrie further explores the possibilities of multiple-phase watercolor techniques in two demonstrations: an underpainting in limited color followed by a full-color overpainting; and an underpainting and overpainting that are both in a full range of colors. To show how color and texture can enhance one another, you'll watch a demonstration of the drybrush technique. Then the artist shows how to mix watercolors directly on the paper in a demonstration of the wet-into-wet technique. Finally, Petrie shows how to achieve the vibrant color of the Impressionists.

Light and Shade. The transparency of watercolor makes this an ideal medium for capturing the effects of light in nature. And since there *is* no color without light, the final section of *Color in Watercolor Painting* is devoted to the subject of light and shade. You'll learn how to use watercolor to render the effects of light on geometric and nongeometric forms; how to capture the effects of light as it changes direction *and* changes with the weather; and finally, how to analyze the pattern of light and shade in your subject to paint high-key, middle-key, low-key, high-contrast, medium-contrast, and low-contrast subjects, step-by-step.

Studio Setup. Whether you work in a studio or just a corner of a bedroom or kitchen, it's important to be methodical about setting up. Let's review the basic equipment and its arrangement.

Brushes for Watercolor. You'll need just a few brushes for watercolor painting—but you should buy the very best brushes you can afford. You can perform every significant painting operation with just four soft-hair brushes, whether they're expensive sable, less costly oxhair or soft nylon, or perhaps some blend of inexpensive animal hairs. All you really need are a big number 12 round and a smaller number 7 round, plus a big 1″ (25 mm) flat and a second flat about half that size.

Paper. The best all-purpose watercolor paper is moldmade 140-pound stock in the *cold-pressed* surface (called a "not" surface in Britain), which you ought to buy in the largest available sheets and cut into halves or quarters. The most common sheet size is 22″ x 30″ (55 x 76 cm). This paper has a distinct texture, but it's not as irregular as the surface called *rough*. Later you might like to try both rough and smooth paper or illustration board.

Drawing Board. The simplest way to support your paper while you work is to tack or tape the sheet to a piece of hardboard, cut just a little bigger than a full sheet or half sheet of watercolor paper. You can rest this board on a tabletop, perhaps propped up by a book at the back edge so the board slants toward you. You can also rest the board in your lap or even on the ground. Art supply stores carry more expensive *wooden* drawing boards to which you tape your paper. At some point, you may want to invest in a professional drawing table, with a top that tilts to whatever angle you find convenient. But you can easily get by with an inexpensive piece of hardboard, a handful of thumbtacks (drawing pins) or pushpins, and a roll of masking tape 1″ (25 mm) wide to hold down the edges of your paper.

Palette or Paintbox. Some professionals just squeeze out and mix their colors on a white enamel tray—which you can probably find in a shop that sells kitchen supplies. The palette made *specifically* for watercolor is white metal or plastic with compartments into which you squeeze tube colors, plus a mixing surface for producing quantities of liquid color. For working on location, it's convenient to have a metal watercolor box with compartments for your gear. But a toolbox or a fishing tackle box—with lots of compartments—will do just as well. If you decide to work outdoors with pans of color (more about these in a moment), buy an empty metal box that's equipped to hold pans, and then buy the selection of colors listed in this book. Don't buy a box that contains preselected pans of color.

Odds and Ends. You'll also need some single-edge razor blades or a knife with a retractable blade (for safety) to cut paper. Paper towels and cleansing tissues are useful, not only for cleaning up, but for lifting wet color from a painting in progress. A sponge is excellent for wetting paper, lifting wet color, and cleaning up spills. You obviously need a pencil for sketching your composition on the watercolor paper before you start to paint: buy an HB drawing pencil in an art supply store or just use an ordinary office pencil. To erase the pencil lines when the watercolor is dry, you'll need a kneaded rubber (or "putty rubber") eraser, so soft that you can shape it like clay and erase a pencil line without abrading the delicate surface of the sheet. You'll also need three wide-mouthed glass jars big enough to hold a quart or a liter of water (you'll find out why in a moment). If you're working outdoors, a folding stool is a convenience—and insect repellent is a *must*!

Work Layout. Lay out your supplies and equipment in a consistent way, so that everything is always in its place when you reach for it. Directly in front of you is your drawing board with your paper tacked or taped to it. If you're right-handed, place your palette and those three wide-mouthed jars to the right of the drawing board. In one jar, store your brushes, hair end up; don't let them roll around on the table and get squashed. Fill the other two jars with clear water. Use one jar of water as a "well" from which you draw water to mix your colors; use the other for washing your brushes. (Be sure to change the water when it gets really dirty.) Keep the sponge in a corner of your palette, with the paper towels nearby, ready for emergencies. Line up your tubes of color someplace where you can get at them quickly—possibly along the other side of your drawing board—when you need to refill your palette. Reverse these arrangements if you're left-handed.

Palette Layout. In the excitement of painting, it's essential to dart your brush at the right color instinctively. So establish a fixed location for each color on your palette. There's no one standard arrangement. One good way is to line up your colors in a row with the *cool* colors at one end and the *warm* colors at the other. The cool colors would be black, two or three blues, and green, followed by the warm yellows, orange, reds, and browns. The main thing is to be consistent in your arrangement, so you can find your colors when you want them.

Tubes and Pans. Watercolors are normally sold in collapsible metal tubes about as long as your thumb, and in metal or plastic pans about the size of the first joint of your thumb. The tube color is a moist paste that you squeeze out onto the surface of your palette. The color in the pan is dry, but dissolves as soon as you touch it with a wet brush. The pans, which lock neatly into a small metal box made to fit them, are convenient for rapid painting on location. But the pans are useful mainly for small pictures—no more than twice the size of this page—because the dry paint in pans is best for mixing small quantities of color. The tubes are more versatile and more popular. The moist color in the tubes will quickly yield small washes for small pictures and big washes for big pictures. If you must choose between tubes and pans, buy the tubes.

Color Selection. All the pictures in this book are painted with just a dozen tube colors. Once you learn to mix the various colors on your palette, you'll be astonished at the range of colors you can produce. Seven of these eleven colors are *primaries*—blues, reds, and yellows. (Primaries are colors you can't create by mixing other colors.) There are just two *secondaries*, orange and green. (Secondaries are colors you *can* create by mixing two primaries. For example, you can mix a rich variety of greens by combining various blues and yellows, plus many different oranges by combining reds and yellows, so you could really do without the secondaries. But it does save time to have them.) Finally, there are two browns, plus black.

Blues. Ultramarine blue is a dark, soft blue that produces a rich variety of greens when blended with the yellows, and a wide range of grays, browns, and brown-grays when mixed with the two browns on your palette. Phthalocyanine blue is a clear, brilliant hue that has tremendous tinting strength—which means that it must be used in small quantities because it tends to dominate any mixture. Cerulean blue is a light, bright blue that's popular for skies and atmospheric effects. It's an optional hue you might like to have available.

Reds. Alizarin crimson is a bright red with a hint of purple. It produces lovely oranges when mixed with the yellows, subtle violets when mixed with the blues, and rich darks when mixed with green. Cadmium red light is a dazzling red with a hint of orange, producing rich oranges when mixed with the yellows, coppery tones when mixed with the browns, and surprising darks (not violets) when mixed with the blues.

Yellows. Cadmium yellow light is bright and sunny, producing luminous oranges when mixed with the reds and rich greens when mixed with the blues. Yellow ochre is a much more subdued, tannish yellow that produces subtle greens when mixed with the blues and muted oranges when mixed with the reds. You'll find that both cadmiums tend to dominate mixtures, so add them just a bit at a time. Some watercolorists find cadmium yellow *too* strong—and just a bit too opaque—so they substitute new gamboge, which is bright, very transparent, and less apt to dominate a mixture.

Orange. Cadmium orange is a color that you really could create by mixing cadmium yellow light (or new gamboge) and cadmium red light. But it's a beautiful, sunny orange, and convenient to have ready-made.

Green. Viridian is another optional color—you can mix lots of greens—but convenient, like cerulean blue and cadmium orange. Just don't become dependent on this one green. Learn how many other greens you can mix by combining blues, blacks, and yellows. And see how many other greens you can make by modifying viridian with other colors.

Browns. Burnt umber is a dark, subdued brown that produces lovely brown-grays and blue-grays when blended with the blues, subtle foliage colors when mixed with green, and warm autumn colors when mixed with reds, yellows, and oranges. Burnt sienna is a bright orange-brown that produces a very different range of blue-grays and brown-grays when mixed with the blue plus rich, coppery tones when blended with reds and yellows.

Black. This is a controversial color among watercolorists. Many painters don't use black because they can mix more interesting darks—containing a fascinating hint of color—by blending such colors as blue and brown, red and green, orange and blue. And blue-brown mixtures also make more interesting grays. However, ivory black is worth having on your palette if you use it as a *color*. For example, mixed with the yellows, ivory black produces beautiful, subdued greens for landscapes; and mixed with blues and greens, ivory black produces deep, cool tones for coastal subjects. If you find ivory black too strong, you might like to try Payne's gray, which is softer, lighter, and a bit bluer, making it popular for painting skies, clouds, and atmosphere.

No White. Your sheet of watercolor paper provides the only white you need. You lighten a color mixture with water, not with white paint.

Talking About Color. When artists discuss color, they use a number of words that may or may not be familiar to you. Because many of these words will appear in this book, this page will serve as a kind of informal glossary of color terms.

Hue. When you talk about color, the first thing you'll probably do is talk about its hue. That is, you'll name the color. You'll say that it's red or blue or green. That name is the *hue*.

Value. As you begin to describe that color in more detail, you'll probably say that it's dark or light or something in between. Artists use the word *value* to describe the comparative lightness or darkness of a color. In judging value, it's helpful to pretend that you're temporarily colorblind, so that you see all colors as varying tones of black, gray, and white. Thus, yellow becomes a very pale gray—a light or high value. In the same way, a deep blue is likely to be a dark gray or perhaps black—a low or dark value. And orange is probably a medium gray—a middle value.

Intensity. In describing a color, artists also talk about its comparative intensity or brightness. The opposite of an intense or bright color is a subdued or muted color. Intensity is hard to visualize, so here's an idea that may help: pretend that a gob of tube color is a colored light bulb. When you pump just a little electricity into the bulb, the color is subdued. When you turn up the power, the color is more intense. When you turn the power up and down, you don't change the hue or value—just the brightness or *intensity*.

Temperature. For psychological reasons that no one seems to understand, some colors look warm and others look cool. Blue and green are usually classified as cool colors, while red, orange, and yellow are considered warm colors. Many colors can go either way. A bluish green seems cooler than a yellowish green, while a reddish purple seems warmer than a bluish purple. And there are even more subtle differences: a red that has a hint of purple generally seems cooler than a red that has a hint of orange; a blue with a hint of purple seems warmer than a blue that contains a hint of green. All these subtle differences come under the heading of *color temperature.*

Putting It All Together. When you describe a color, you generally mention all four of these factors: hue, value, intensity, and temperature. If you want to be very technical, you might describe a particular yellowish green as "a high-value, high-intensity, warm green." Or you might say it more simply: "a light, bright, warm green."

Primary, Secondary, and Tertiary Colors. The primaries are blue, red, and yellow—the three colors you can't produce by mixing other colors. To create a secondary, you mix two primaries: blue and red to make violet; blue and yellow to make green; red and yellow to make orange. The six tertiary colors are blue-green, yellow-green, blue-violet, red-violet, red-orange, and yellow-orange. As you can guess, the tertiaries are created by mixing a primary and a secondary: red and orange produce red-orange, yellow and orange produce yellow-orange, etc. You can also create tertiaries by mixing uneven amounts of two primaries: a lot of red and a little yellow will make red-orange; a lot of blue and a little yellow will make blue-green, and so forth.

Complementary Colors. The colors that are opposite one another on the color wheel are called *complementary colors* or just *complements*. As you move your eye around the color wheel, you'll see that blue and orange are complements, blue-violet and yellow-orange are complements, violet and yellow are complements, and so forth. Memorize these pairs of complementary colors, since this information is useful in color mixing and in planning the color scheme of a painting. One of the best ways to subdue a color on the palette—to reduce its intensity—is to add a touch of its complement. On the other hand, one of the best ways to brighten a color in your painting is to place it next to its complement. Placing complements side by side is also one of the best ways to direct the viewer's attention to the center of interest in a painting, since this always produces a particularly vivid contrast.

Analogous Colors. When colors appear next to one another—or fairly close—on the color wheel they're called *analogous* colors. They're considered analogous because they have something in common. For example, blue, blue-green, green, and yellow-green are analogous because they *all* contain blue. Planning a picture in analogous colors is a simple, effective way to achieve color harmony.

Neutral Colors. Brown and gray are considered neutral colors. A tremendous variety of grays and browns—which can be quite colorful in a subtle way—can be mixed by combining the three primaries or any pair of complements in varying proportions. For example, various combinations of reds and greens make a diverse range of browns and grays, depending upon the proportion of red and green in the mixture.

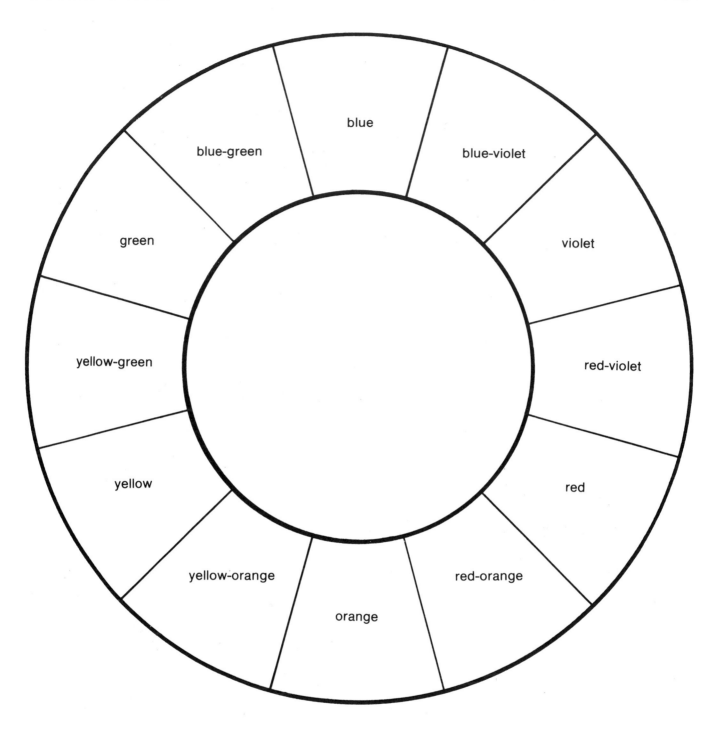

Classifying Colors. It's helpful to memorize the classic diagram that artists call a *color wheel*. This simple diagram contains the solutions to a surprising number of color problems you may run into when you're working on a painting. For example, if you want a color to look *brighter*, you'd place a bit of that color's complement nearby to strengthen it. You'll find the complement directly across the wheel from the other color. On the other hand, if you want to *subdue* that original color, you'd blend a touch of its complement into the original color. If color harmony is your problem, one of the simplest ways to design a harmonious color scheme is to choose three or four colors that appear side-by-side on the color wheel, and build your painting around these *analogous* colors. Then, to add a bold note of contrast, you can enliven your color scheme by introducing one or two of the complementary colors that appear on the opposite side of the wheel from the original colors that you've chosen for your painting.

Plan Your Mixtures. Certainly the most important "rule" of color mixing is to plan each mixture before you dip your brush into the wet colors on your palette. Don't poke your brush into various colors and scrub them together at random, adding a bit of this and a bit of that until you get what you want—more or less. Instead, at the very beginning, you must decide which colors will produce the mixture you want. Try to limit the mixture to just two or three tube colors plus white—or water if you're working with watercolor—to preserve the brilliance and clarity of the mixture.

Don't Overmix. No one seems to know why, but if you stir them around too long on the palette, colors *lose* their brilliance and clarity. So don't mix your colors too thoroughly. As soon as the mixture looks right, stop.

Work with Clean Tools. To keep each mixture as pure as possible, be sure your brushes and knives are clean before you start mixing. If you're working with oil paint, rinse the brush in solvent and wipe it on a scrap of newspaper before you pick up fresh color or, better still, try mixing with a palette knife, wiping the blade clean before you pick up each new color. If you're working with watercolor or acrylic, rinse the brush in clean water, making sure to replace the water in the jar as soon as it becomes dirty.

Getting to Know Your Medium. As you experiment with different media, you'll discover that subtle changes take place as the color dries. When you work in oil, you'll discover that it looks shiny and luminous when it's wet, but often "sinks in" and looks duller after a month or two, when the picture is thoroughly dry. Some painters restore the freshness of a dried oil painting by brushing or spraying it with retouching varnish. A better way is to use a resinous medium—damar, mastic, copal, or alkyd—when you paint. A resinous medium preserves luminosity because it's like adding varnish to the tube color. If you're working in watercolor, you'll find that watercolor becomes paler as it dries. To make your colors accurate, you'll have to make all your mixtures darker than you want them to be in the final picture. And if you're using acrylic, you'll discover that, unlike watercolor, acrylic has a tendency to become slightly more subdued when it dries. So you may want to exaggerate the brightness of your acrylic colors as you mix them.

Lightening Colors. The usual way to lighten oil color is to add white, while the usual way to lighten watercolor is simply to add water. If you're working with acrylic, you can do both: you can add white to lighten an opaque mixture and water to lighten a transparent one. However, it's not always that simple. White may not only lighten the color; it may actually change it. For example, a hot color like cadmium red light rapidly loses its intensity as it gets paler, so it may be a good idea to restore its vitality by adding a touch of a vivid color (like alizarin crimson) in addition to white or water. If the crimson turns your mixture just a bit too cool, you may also want to add a speck of cadmium yellow. In other words, as you lighten a color, watch carefully and see if it needs a boost from some other hue.

Darkening Colors. The worst way to darken any color is by adding black, because it tends to destroy the vitality of the original hue. Instead, try to find some other color that will do the job. For example, try darkening a hot red or orange—such as cadmium red light, alizarin crimson, or cadmium orange—with a touch of burnt umber or burnt sienna. Or darken a brilliant hue like cadmium yellow light by adding a more subdued yellow like yellow ochre. Although darkening one rich color with another may produce slight changes in hue or intensity, this is preferable to adding black.

Brightening Colors. Experimentation is the only way to find out how to brighten each color on your palette, since every color behaves in its own unique way. For example, a touch of white (or water) will make cadmium yellow light look brighter, while that same touch of white will make cadmium orange look more subdued. As it comes from the tube, cadmium red light looks so brilliant that it's hard to imagine any way to make it look brighter, but a touch of alizarin crimson will do it. Ultramarine blue looks dull and blackish as it comes from the tube, yet a touch of white (or water) will bring out the richness of the blue. It will become even brighter if you add a tiny hint of green.

Subduing Colors. Again, the first rule is to avoid black, which *will* subdue your color by reducing it to mud. Instead, look for a related color, one that's less intense than the color you want to subdue. The color tests described in the oil, watercolor, and acrylic parts of this book will show you how each color behaves when it's mixed with every other color on your palette. The texts should also help you decide which color to choose when you want to lessen another color's intensity. For example, a touch of yellow ochre is often a good way to reduce the intensity of the hot reds, oranges, and yellows. And a speck of burnt umber will reduce the intensity of blue without a major color change.

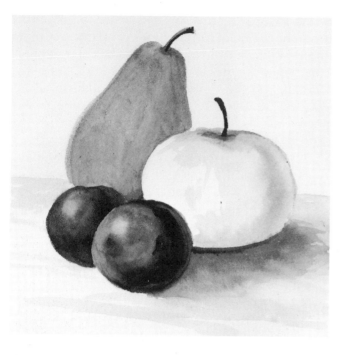

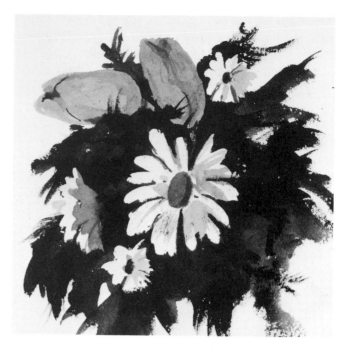

Fruit. The best way to learn about values is to make a series of watercolor studies (like this one) entirely in black-and-white washes. When each color is seen as pure value, the green pear becomes a medium gray, the yellow apple is almost white, and the purple plums are a deep gray that turns black in the shadows.

Flowers. For these little watercolor studies, just squeeze ivory black onto your palette and add water to create different shades of gray. Leave the paper bare to get pure white. In this flower study, the yellow petals are bare paper, the oval blossoms at the top (which are actually orange) become a medium gray, and the green leaves are mainly black.

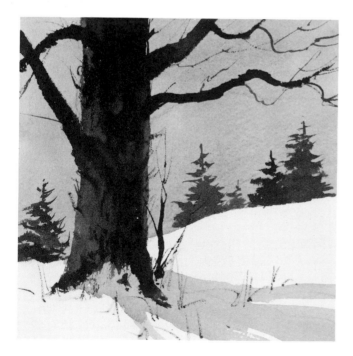

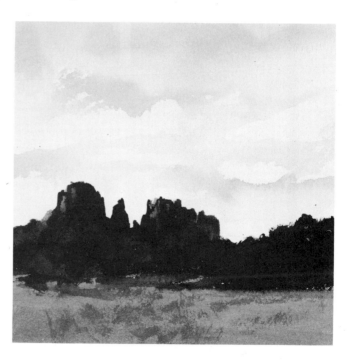

Winter. When you paint value studies outdoors, you'll often find that your subject consists of four major values. In this scene, the dark brown tree is a dark gray with blackish shadows. The distant evergreens are a slightly lighter gray. The blue sky and the bluish shadow on the snow are a pale gray. And the snow itself is the pure white paper.

Desert. Here's another outdoor value study in four values. The reddish brown of the rock formation is now a deep gray that's almost black. The tannish sand in the foreground is a medium gray. The blue patches of sky are rendered as a pale gray. And the white clouds are bare white paper.

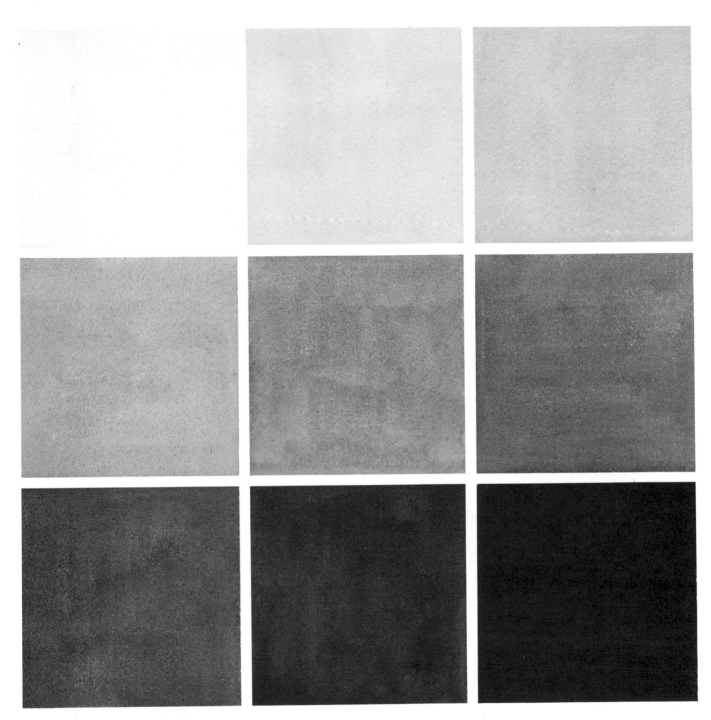

Classifying Values. You'll find it helpful to paint a chart of values to hang on the studio wall—and memorize. Then, when you see a color in nature and try to decide how light or dark the color mixture should be, you can find the right value on this chart or *value scale*. To make such a chart, draw a checkerboard pattern with nine squares on a sheet of watercolor paper, as you see here. The chart actually represents ten values, when the white of the bare paper is counted as your lightest value. To block in the values, add plenty of water to your ivory black to paint the palest square. Keep adding less water for each square until you get to pure black. You may find it easier to reverse the process, starting with the darkest square at the bottom of the value scale, then adding pro- gressively more water to each square until you get to the top of the scale. Don't be disappointed if you don't do well at first. It takes practice to learn just how much water to add for each value. And you must remember that watercolor lightens as it dries. You may find it simpler to paint each square on a separate scrap of paper, and save only the squares that turn out well. When you've got nine squares that seem right, you can paste them down. The watercolor washes in the squares don't have to be absolutely smooth. Just get all the values right. (To help you to remember the values, you may want to assign a number to each square.) Yes, nature *does* contain many more than ten values. But most artists find that these ten values come reasonably close to matching nearly every color.

Step 1. There's no point in trying to paint the infinite and bewildering number of values in nature. Many watercolorists find that they can paint a convincing landscape by simplifying nature to just three values. The artist begins this three-value landscape with a pencil drawing on cold pressed paper. Diluting ivory black with lots of water, he covers the whole sheet with a pale gray—the lightest tone on his value scale—that's actually the delicate tone of the sky. When this pale value is dry, he adds less water to the black and covers the grassy field with a medium gray—around the middle of the value scale. At this point, the picture contains two of the major values in the landscape.

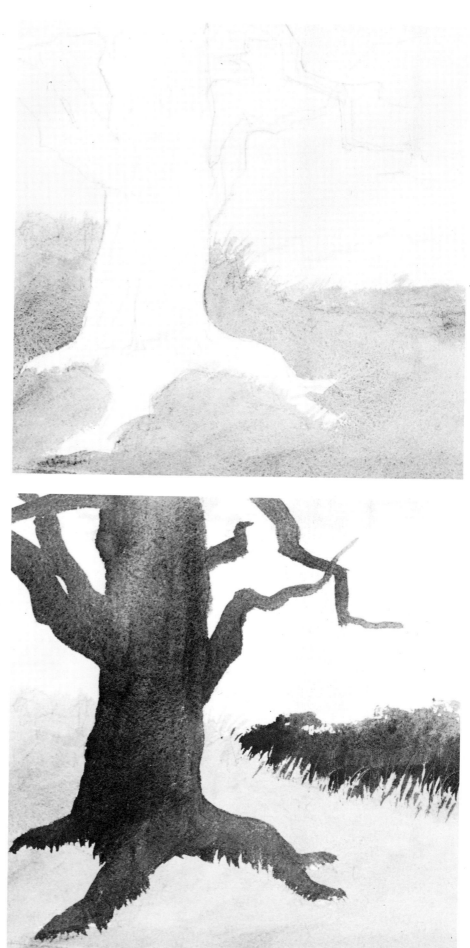

Step 2. Adding much less water to the black on his palette, the artist creates a deep gray, found on the lower part of the value scale. He washes this gray over the trunk, roots, and branches, and then places the same value on the clump of distant trees beyond the edge of the grassy field. Notice how he places thin, ragged strokes along the lower edges of the roots and at the edge of the field to suggest pale blades of grass overlapping the darker shapes. Now the artist has a clear idea of his three main values: the *light* value of the sky, the *middletone* of the meadow, and the *dark* of the foreground tree and the clump of trees over the brow of the hill. So far, the painting is just a kind of "poster" that shows the three values as flat tones without much detail.

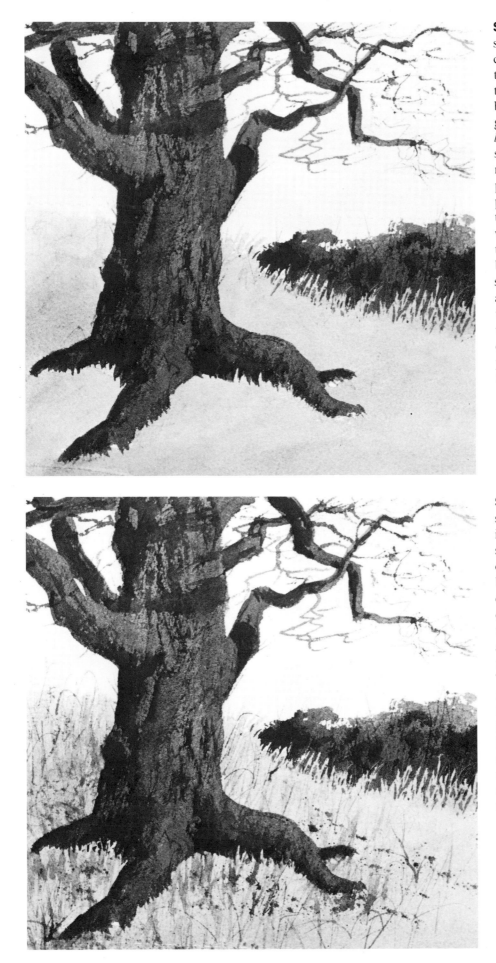

Step 3. Within the two darkest shapes—the tree and the distant clump of foliage—the artist begins to add *slightly* darker strokes for texture and detail, like twigs and branches. The ragged bark is suggested by a technique called *dry-brush*. He dampens the brush with a small amount of darker color, and moves the brush lightly over the paper. The irregular texture of the paper breaks up the strokes. He uses the same method for the shadows within the distant foliage, but turns the brush on its side to make broader, rougher strokes. These shadows, textures, and details are a bit darker than the underlying tones, but the painting's three-value scheme remains basically unchanged. To check this, half-close your eyes and you'll still see the three dominant values.

Step 4. The artist adds slender strokes to the grassy field, suggesting blades of grass and weeds. He suggests pebbles and other details on the meadow by shaking a wet brush over the paper to spatter droplets of color. These touches of detail don't alter the basic value of the meadow. Half-close your eyes again and you'll see the three values: light, middletone, and dark. There are two important reasons for learning to simplify values. First, it's much easier to mix a color if you first decide whether it's a light, a middletone, or a dark. Second, a simplified value scheme produces a bolder, more dramatic, and more convincing pictorial design that actually looks *truer* to nature!

Step 1. When three values aren't enough to describe a subject, try *four* values: a dark, a light, and *two* middletones, one lighter and one darker. (Occasionally, you can add a third middletone, but two are usually enough.) This is a more complex landscape than the preceding three-value demonstration, so this demonstration will need four values. The casual, rather scribbly pencil drawing indicates all the major shapes on the watercolor paper, except for the clouds and water. Over the entire sheet, the artist washes the lightest value—lots of water added to a dab of black. This represents the delicate blue of the sky and its reflected color in the water.

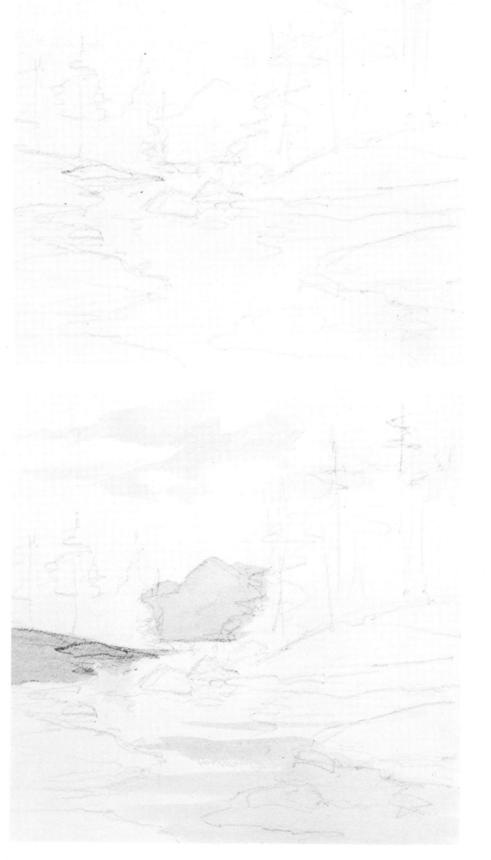

Step 2. Adding slightly less water to the black on his palette, the artist brushes in the lighter of the two middletones. This value represents the pale, luminous tone of the sky, the shapes of the moving stream, the reflections of the clouds in the water, the distant mountain peaks, and the wedge-shaped piece of shore at the extreme left. (That shore may look somewhat darker because of the heavier pencil strokes, but you'll soon see that it's the lighter of the two middletones.) He waits for the paint to dry. The artist has now painted two of his four major values on the watercolor paper.

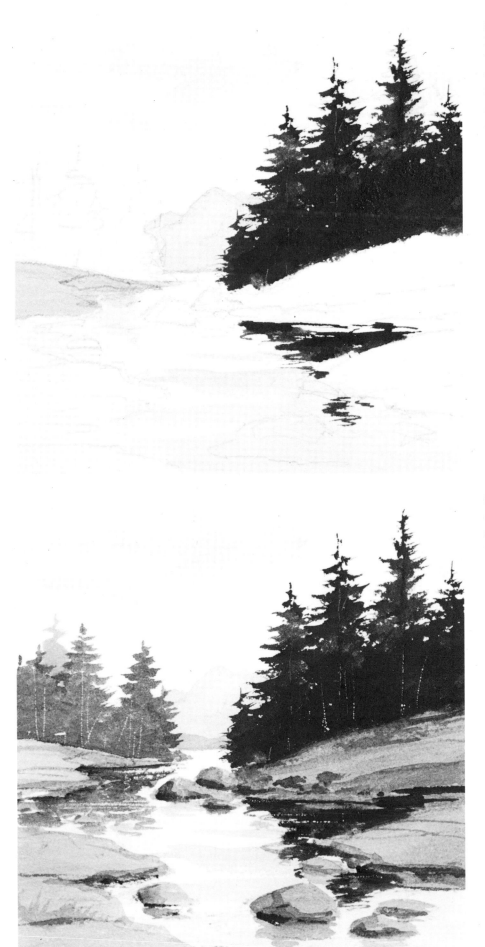

Step 3. Having established the lighter values, the artist blocks in the darkest tone. This is the shadowy mass of evergreens on the right, probably a blackish or bluish green in nature, becoming a deep gray that's almost black in this value study. He then repeats this dark value in the reflections in the stream. At this stage, the painting contains three of the four major values: the pale tone of the sky and water; the *lighter* of the two middletones in the clouds, peaks, shore, and water; and the dark tones of the evergreens and their reflections. Notice the brushwork in the evergreens. The artist suggests the characteristic shapes of the branches by pressing the side of a round brush against the center of the tree, then pulling the brush sideways as he lifts it away.

Step 4. In nature, the more distant evergreens on the left shore are a soft green, which the artist renders now as a dark middletone and carries down into the water to suggest reflections. He paints the other shapes of the shore with the two middletones: lighter for the sunlit areas and darker for the shadows. He paints the rocks with three values: the lighter middletone for the sunlit planes; the darker middletone for the shadowy side planes; and the dark for the deepest shadow under the rocks. The point of the brush adds details such as grass among the rocks. When the paper is bone dry, he uses a razor blade to scratch a few trunks among the dark evergreens and some streaks of light into the water. Despite the amount of detail, you still see four dominant values.

Getting to Know Watercolors. Watercolor dries so rapidly that you've got to make your color mixing decisions quickly and carry the color from palette to paper without a moment's hesitation. Thus, you must know the color so intimately that you instinctively reach for the right one, visualizing in advance how it's going to behave. The best way to learn what your colors can do is to conduct a series of mixing tests and record the results on simple color charts that you can study and memorize at your leisure.

Making Color Charts. To prepare your charts, buy an inexpensive pad of cold-pressed paper (called "not" in Britain) about the size of the page you're now reading. If you can save money by buying the paper in large sheets, cut up the sheets to make your charts. With an HB drawing pencil or an ordinary office pencil, draw a series of boxes on the paper with the aid of a ruler, to form a kind of checkerboard. Make the boxes 2″ to 3″ (50 to 76 mm) square, giving you enough room to paint a single color sample inside each box and to write the names of the colors. Make a separate sheet for each color on your palette, so you'll have enough boxes to mix that color with each of the others.

Adding Water. First you'll see how each tube color behaves when you add water. Water makes the tube colors fluid enough to brush across the paper, and also lightens the colors in the same way that white lightens oil paint. Now just make a few parallel strokes of each color, adding very little water to the first strokes at the left and adding a lot more water to the final strokes at the right. The darker area of the sample will show you how the color looks as it comes straight from the tube, while the paler area will show you how the color looks when it's diluted. Let the samples dry and study them carefully. You'll see that each color has its own special character. For example, phthalocyanine blue is so powerful that you'll need a great deal of water to dilute it—and even when you do add a lot of water, you'll still get a rich, vivid blue. On the other hand, the more subdued ultramarine blue has less *tinting strength*; you'll need much less water to produce a pale wash of ultramarine. You'll also discover that watercolor lightens as it dries, so remember to make your mixtures a bit "too dark."

Mixing Two Colors. Next, you'll mix each color on your palette with every other color. The best way is to make a few broad strokes in the left-hand side of your box. Then, while those first few strokes are wet and shiny, add some strokes of the second color in the right-hand side of the box, carefully bringing the second color over to meet the first and letting them flow together. At the point where they flow together, you'll get a third color, showing you how the two colors mix. If you do this carefully, the dried sample will contain three ragged bands of color: the original two colors at the right and left, and the mixture in the middle. Don't worry if the two colors flow together so swiftly that they disappear and all you've got left is the mixture. After all, it's the mixture that you're really trying to record. (Don't forget to write the names of the colors somewhere in the box.) Now analyze the dried chart to see what you can learn. Some colors, like cadmium red light and cadmium yellow light, flow together smoothly to form a soft, glowing mixture. Others, such as ultramarine blue and burnt sienna, may form a more granular, irregular mixture. Complements like viridian and alizarin crimson make lovely grays and browns. And some colors—like phthalocyanine blue again—are so powerful that they obliterate the other colors they're mixed with. So, the next time you add phthalocyanine blue, for instance, to alizarin crimson to make purple, add more crimson and just a *speck* of blue.

Optical Mixing. When you brush two hues together on your palette, you're creating a *physical* mixture. The two colors are physically combined to create a third color. But because watercolor is essentially transparent and quick-drying, experienced watercolorists often mix their colors in a different way: they brush one color over the paper, let it dry, and then brush a second color over the first. The two colors mix in the viewer's eye like two overlapping sheets of colored glass to create a third color—an *optical* mixture. Try a series of optical mixtures. Dilute each of your tube colors with a fair amount of water and brush a few strokes of color into the left-hand side of the box, leaving some bare paper at the right. When the first color is dry—*absolutely* dry—dilute a second color with water and brush over the dry color. Make the first few strokes of the second color on the bare paper at the right, and then carry some strokes halfway over the patch of dried color. When both layers of color are completely dry, you'll have three bands of color: the original, unmixed colors at either end, and a third band of color in the middle—the optical mixture. Compare physical and optical mixtures of the same two colors. The mixtures will be equally beautiful, but they'll often be different. The physical mixture tends to look bolder, stronger, but the optical mixture has a special kind of clarity, purity, and inner light.

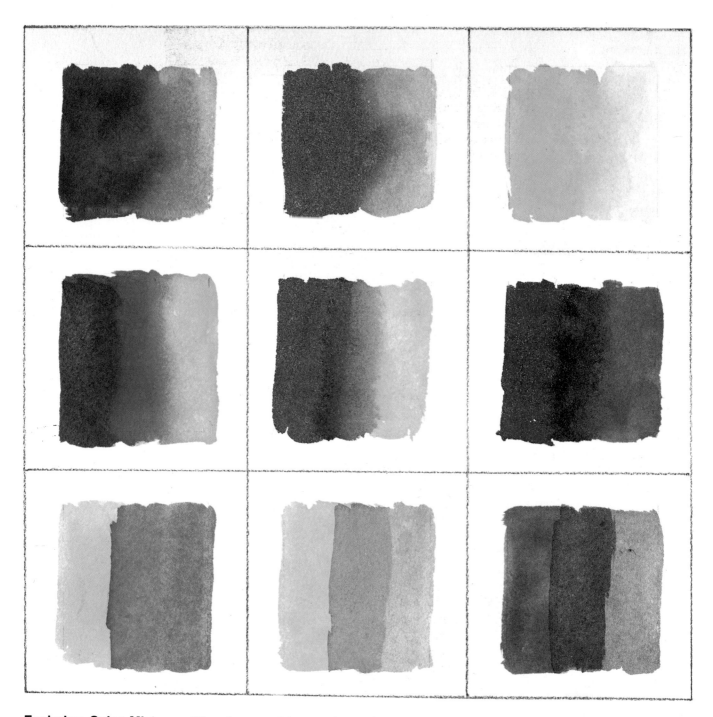

Exploring Color Mixtures. The chart on this page is actually a composite, showing typical boxes from the various color charts you should make. In the top row, from left to right, you can see how alizarin crimson, ultramarine blue, and cadmium yellow react when they're diluted with water. With a small amount of water, alizarin crimson is a bright, cool red that becomes a cool pink with more water. The dark, subdued ultramarine blue turns soft and atmospheric as you add more water. Cadmium yellow, which is bright and sunny, is so powerful that you need a great deal of water to produce a pale, delicate yellow. In the three samples in the second row, a wet stripe of one color is painted at the left, a wet stripe of another color is painted at the right, and the two stripes are then brushed together to create a third color. From left to right, you see that alizarin crimson and cadmium yellow meet to produce a bright orange, ultramarine blue and cadmium yellow produce a subdued green, and ultramarine blue and alizarin crimson produce a subdued violet. These three samples are all *physical* mixtures: that is, two colors are blended to produce a third. On the other hand, the colors in the third row are *optical* mixtures. To make an optical mixture, one color is painted across two-thirds of the box and allowed to dry. Then a second color is painted from right to left, partly overlapping the first color to create a third color. The overlapping colors are considered an optical mixture because the colors mix in your *eye*. Compare the optical mixtures with the physical mixtures, bearing in mind that the *same* tube colors are used in the second and third rows.

Complementary Background. From painting your color charts, you've discovered how to alter, adjust, and control colors by mixing them with water and with each other. But you can also heighten or subdue the intensity of a color by carefully planning color *relationships.* That is, a color can look brighter or more subdued, depending upon the color you place next to it. For example, these yellow apples look especially bright because the artist has placed them against a violet background. According to the color wheel that appears earlier in this book, violet is the complement of yellow. (Since complements brighten one another when they're placed side-by-side, *red* apples would look brightest against a *green* background.)

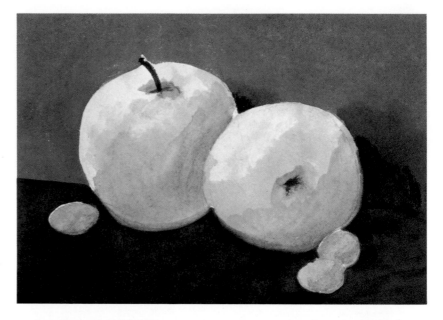

Analogous Background. To subdue a hue rather than brighten it, you can place that color against a background of a similar color. Now when the yellow apples are placed against an orange background, they don't look nearly as bright as they do against the violet background because orange is *analogous* to yellow. That is, orange is fairly close to yellow on the color wheel. If these apples were green, they could be subdued by placing them against a blue background, and if the apples were red, they could be subdued by placing them against an orange background. But look at the little green grapes on the table. They now appear brighter because they've been placed against a reddish background.

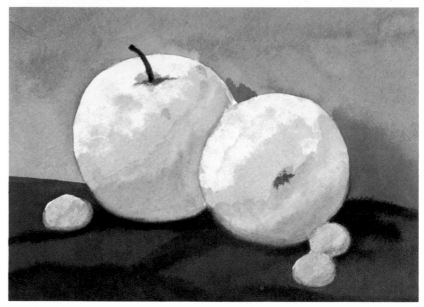

Neutral Background. Placing a color against a complementary background isn't the *only* way to increase intensity. If you'd rather not place two bright colors side by side, you can brighten one of these colors by surrounding it with a neutral color—a gray or a brown or a gray-brown. Thus, the gray wall heightens the intensity of these yellow apples, while the brown of the table brightens the green grapes. Remember two simple rules. To brighten a color, place it next to a complementary hue or a neutral. To subdue a color, place it against an analogous color.

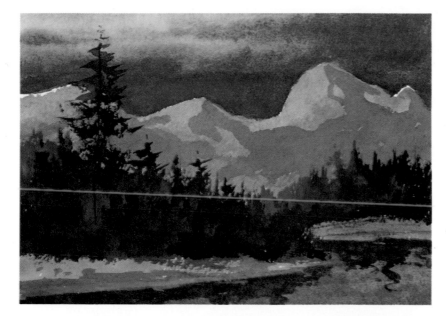

Dark Background. Just as the *intensity* of a color can be controlled by carefully planning your color relationships, so the *value* of a color can be altered by carefully selecting its surroundings. Against a dark, stormy sky, the lighted planes of these mountains look pale and dramatic. The dark value of the sky and the light value of the mountains actually strengthen one another. That is, the sky looks darker and the mountains look lighter.

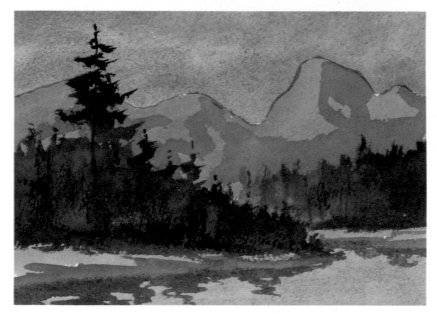

Middletone Background. If you lighten the sky to a middletone, both the sky and the mountain colors are roughly the same value. Thus the contrast between the two areas has been reduced. The reduced contrast makes the picture more benign and the landscape more friendly, as compared with the ominous, dramatic landscape above. Neither value plan is better than the other—they're just different.

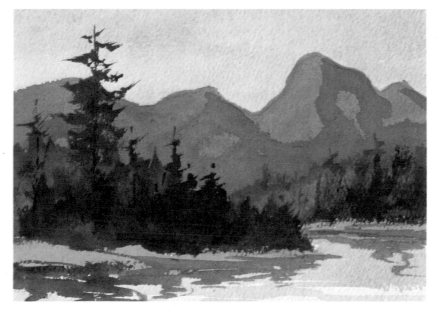

Light Background. The artist now places the mountains against a much paler value. Immediately, the shapes of the mountains become dark silhouettes against the pale sky, and the mood of the picture changes once again. The "rules" are obvious. To make a color look lighter, place it against a darker background. To make it look darker, place it against a lighter background. And if you want to call less attention to a color, place it against a background of roughly the same value.

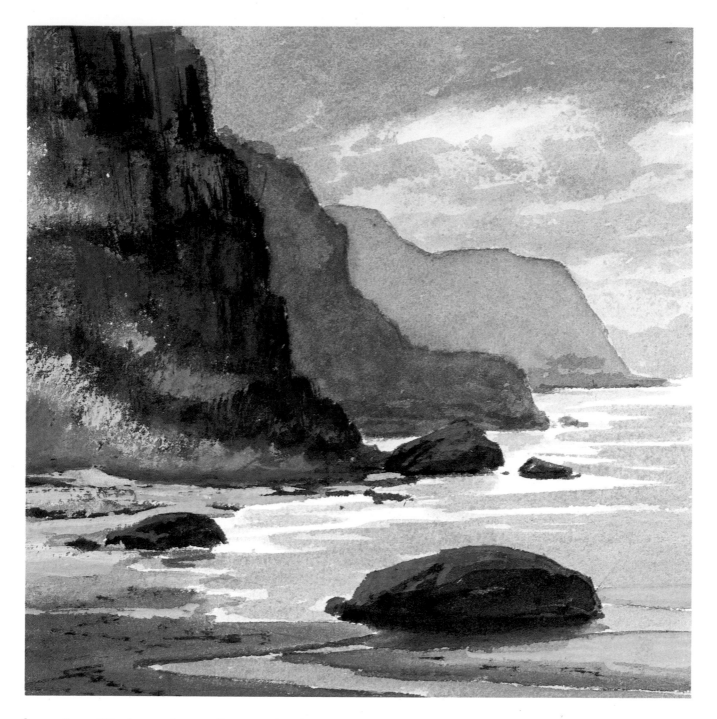

Sunny Day. Whether you're standing on a beach—like the artist painting this picture—in the woods, or on a mountain top, you'll find that the colors in the foreground tend to be brighter, darker, and generally warmer than the colors in the distance. As things move farther away, they tend to grow paler, more subdued, and cooler. In other words, color obeys the "laws" of *aerial perspective*. The effects of aerial perspective are particularly easy to render in watercolor, since the transparency of the medium is ideal for rendering the effects of light and atmosphere. In the foreground of this coastal scene, the artist places his strongest colors (diluted with a moderate amount of water). Thus, the headland at the extreme left is painted in dark, rich colors. When he paints the second headland in the middle distance, the artist adds more water and more cool color. To paint the third, most distant headland, the artist adds still more cool color and a lot more water to paint a delicate, highly transparent wash. Notice the same color effects in the sky and sea. The artist places his strongest colors in the sky that's directly overhead—at the top of the picture—and in the foreground water. Then, as he approaches the horizon, he dilutes his color to produce more delicate tints.

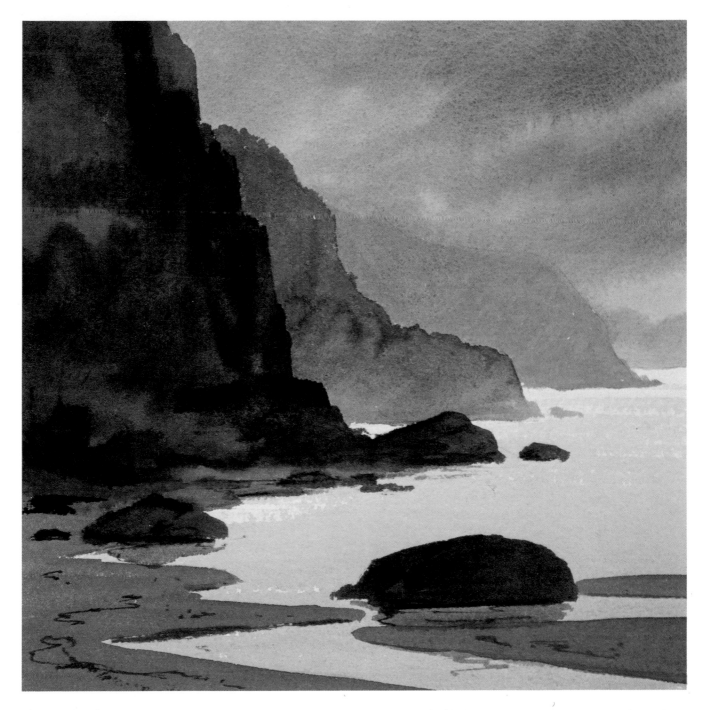

Overcast Day. Although colors are much more subdued on an overcast day, the same "laws" of aerial perspective *still* have a profound influence on a watercolor landscape or seascape. You can mix the subdued colors you'll need for an overcast day by combining a warm color like burnt sienna or burnt umber, and a cool color like ultramarine blue or cerulean blue. To paint the darker, warmer tones of the rocks and the headland in the foreground, the artist adds more warm color and less water. As he moves into the middle distance, he paints the second headland by adding more blue and more water to the mixture. The headland then becomes cooler, paler, and more remote. Finally, he places the third headland far in the distance by mixing a wash that's mostly water and just a hint of color. The sky is again painted in aerial perspective. It's darkest at the top of the picture—right over our heads—and palest at the distant horizon, where the color is mostly clear water.

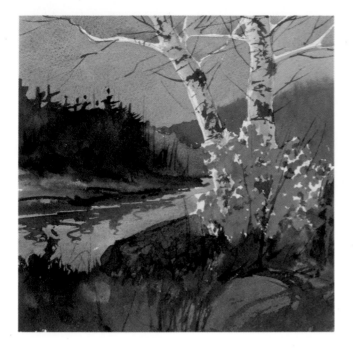

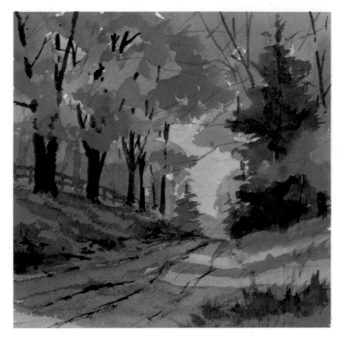

Cool Picture, Warm Notes. This landscape is painted mainly with cool mixtures on the blue-violet side of the color wheel. For contrast, the artist looks across the wheel for the complement of blue, and he adds an orange shrub. To accentuate this cool harmony, he paints a delicate blue wash over the entire picture, leaving only the birches and orange shrub untouched.

Warm Picture, Cool Notes. To paint a picture that's predominantly warm, the artist finds a cluster of analogous hues on the orange side of the color wheel. For a cool note of contrast—which is always welcome—he looks across the wheel to find the complement of orange, and adds some patches of blue sky.

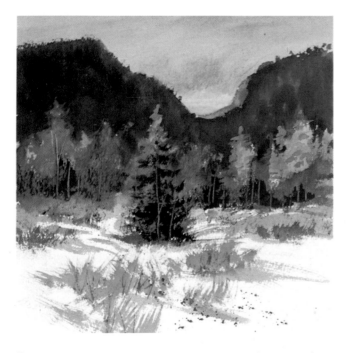

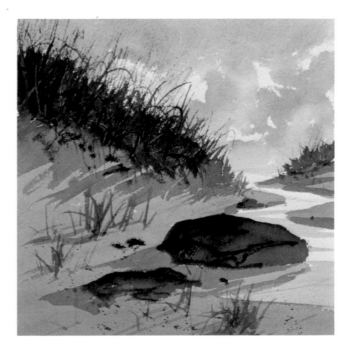

Repeating Colors. Another way to create harmony is to repeat certain colors throughout the picture. The warm tone of the foreground weeds is echoed among the distant trees, on the sunlit edge of the mountain, and at the horizon. The cool tone of the sky is repeated in the cool shadows on the snow.

Repeating Neutrals. Those quiet, inconspicuous colors called *neutrals*—grays, browns, brownish grays, and grayish browns—can be enormously helpful in designing a harmonious picture. Here, the warm neutral shadows move back and forth across the sand, accentuating the warmth of the sunny spots. The cool neutrals in the lower sky are repeated in the water.

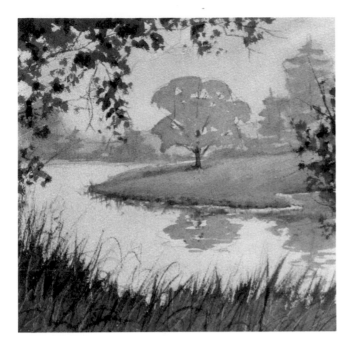

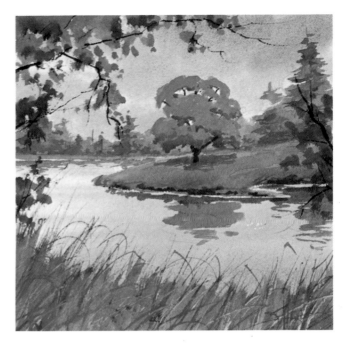

Early Morning. The same scene is gradually transformed into a series of different pictures as the sun rises, travels across the sky, and finally descends again, to be replaced by the moon. In the early morning, colors tend to be soft and delicate. The artist uses his brightest tube colors, but adds a fair amount of water to produce luminous, transparent washes.

Midday. In late morning, at noon, and in early afternoon, the sun is directly overhead and the landscape is bathed in strong light. This is when colors are strongest. The artist now works with pure, bright colors. He adds enough water to make his mixtures flow freely, but paints the midday landscape with much richer and brighter washes than the landscape of early morning.

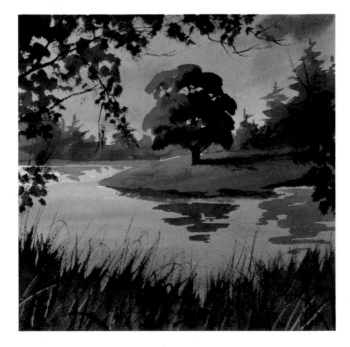

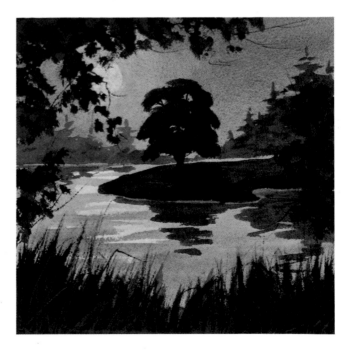

Late Afternoon. Toward the end of the day, when the sun moves downward toward the horizon, colors become more subdued and values become darker. The sun's rays begin to turn orange or red, and the shadows become heavy and somber. There's strong contrast between the lights and the darks in the landscape, such as the dark tree partially silhouetted against the luminous sky.

Night. On a moonlit night, the landscape contains much more color than you might expect, and there are also strong value contrasts. The colors are predominantly cool, with lots of rich blues, greens, and purples. The sky and water reflect a good deal of moonlight. You can see the dark trees and surrounding landscape silhouetted against the lighter sky and water.

Step 1. An excellent way to learn how to see color and value at the same time is to paint a watercolor with a *tonal palette*. This means just two colors, one warm and one cool, intermixed in various proportions to produce a variety of warm and cool tones, and diluted with water for a full value range. This landscape is painted in ultramarine blue and burnt sienna on cold-pressed paper. Over a simple pencil drawing of the main shapes, the artist wets the sky with pure water. Into the wet sky, he brushes ultramarine blue, softened with a touch of burnt sienna. As he moves toward the horizon, he adds more water. With a few dark, wavy strokes, he suggests low-lying clouds.

Step 2. After the sky is thoroughly dry, the artist blocks in the dark mountain with a grayer tone than the sky—produced by adding more burnt sienna to the ultramarine blue. As he moves down to the pale base of the mountain, he adds more water. Still more water is added to this mixture for the small, pale shape of the distant mountain. On the snowy slope to the right, the warm, ragged shapes of the trees are painted mainly with burnt sienna, softened with a touch of ultramarine blue, and diluted with less water than the sky and mountains. Because the paint is thick, containing little water, the wash isn't smooth and even, and the texture of the sheet roughens the strokes.

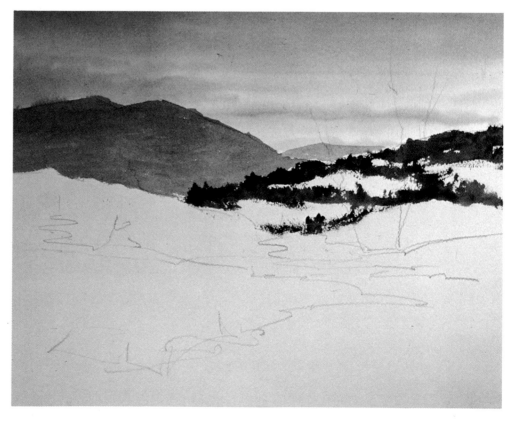

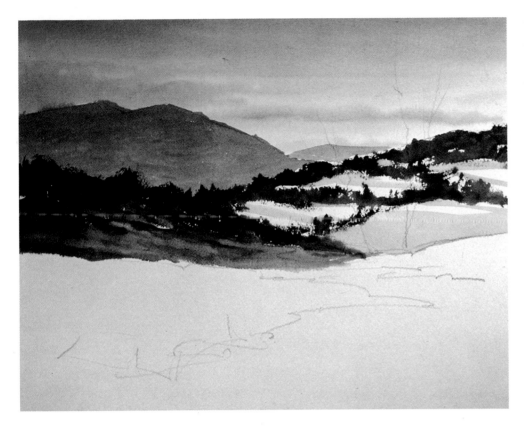

Step 3. The artist mixes a pale version of the wash he's used for the dark mountain—adding much more water—for the delicate shadows on the snow. By now, the dark mountain is dry, so he can paint the overlapping darks of the shadowy slope at the left. To paint the shrubs on top of the slope, he begins with thick strokes of burnt sienna, darkened with ultramarine blue, and diluted with very little water. He adds more blue and more water as he works downward into the paler, cooler tone of the snow in shadow. Where the dark, warm-colored shrubs meet the cool, pale tones of the snow, he adds dark strokes to suggest shadows.

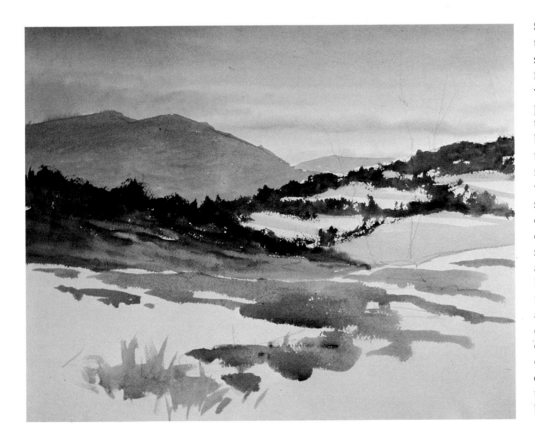

Step 4. In the foreground, the snow partly covers the soil and weeds of a frozen field, which are exposed in warm patches. The artist paints the exposed areas of the field with almost pure burnt sienna, softened by the slightest hint of ultramarine blue and diluted with varying quantities of water, so that some strokes are darker than others. He also decides that the shadowy slope of Step 3 is too dark and too warm. So he wets a bristle brush with pure water, lightly scrubs the dark area, and blots away some of the wet color with a cleansing tissue. When the corrected area is dry, he covers it with a pale wash of ultramarine blue, subdued by a little burnt sienna.

Step 5. The artist mixes a very dark wash—almost black—in which the ultramarine blue and burnt sienna are used almost straight from the tube, diluted with just enough water to make the paint flow smoothly. With his smallest soft-hair brush, the artist paints the evergreens and the bare trees on the shadowy slope. He adds rough strokes of the same mixture among the warm-toned shrubs on the sunny slope at the right, suggesting shadows. Adding more water and a bit more burnt sienna to this dark mixture, he adds dark patches to the big mountain at the left, suggesting clusters of trees among the snow.

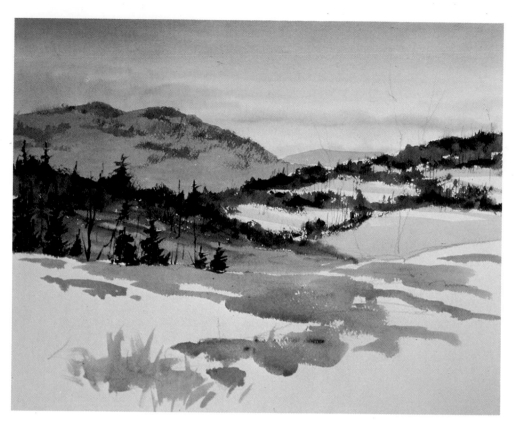

Step 6. Continuing to work with the blackish mixture he's used for the evergreens, the artist draws the slender lines of the leafless trees and their wispy branches. Adding a little more water to the dark evergreen mixture, and warming it with slightly more burnt sienna, he paints the rocks in the foreground field. He adds more water for the scrubby weeds at the far end of the field—and for the rough strokes that suggest the trees just beyond that field.

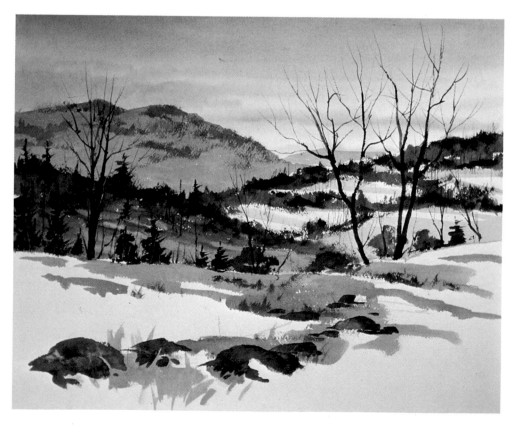

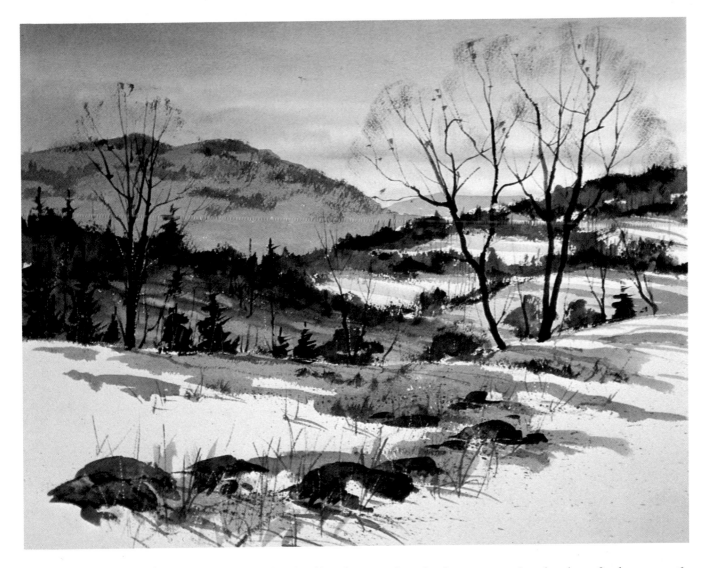

Step 7. As always, the artist saves most of his detail and texture for the final stage. With the tip of his smallest round brush, he adds the cracks and other details in the foreground rocks with the dark mixture he's already used for the tree trunks and the evergreens in the middle distance. Adding a little burnt sienna and slightly more water to this mixture, he dips a medium-sized brush into this blend, and wipes the brush on a paper towel so that the hairs are moist rather than sopping wet. Pressing the hairs of the brush gently against the palm of his hand, he separates them slightly to paint the small blurs of tone that suggest the lacy texture of the dead leaves on the branches of the trees against the sky. Adding more water to make this mixture flow smoothly, he wets the brush thoroughly with this dark, warm tone and brings the brush back to a point by rolling it gently in his hand. With the tip of the brush, he adds the warm blades of grass that come through the snow in the foreground. Darkening the mixture with more ultramarine blue, he loads the brush with wet color. He extends his index finger over the painting and strikes the handle of the brush against the finger, scattering droplets of color across the foreground to suggest bits of debris on the snow. With the same cool, shadowy mixture that he's used to paint the distant mountain, he draws the shadow lines of the grass across the snow in the lower half of the painting. He draws similar shadow lines across the slopes in the middleground to suggest the shadows of the trees on the snow. These shadows are mainly ultramarine blue with just a hint of burnt sienna. The completed painting hardly looks as if it's painted with just two colors. Although the color range is limited, you feel that all the colors of a winter day are really there. Try a painting like this in just two colors. You'll enjoy the challenge and you'll also learn a lot about color mixing. One of the most important lessons you'll learn is that just a slight change in the proportions of a mixture—just a bit more warm or cool color—will make a tremendous difference. Look over the colors on your palette and consider some other combinations of two colors. For example, phthalocyanine blue will work well with either burnt sienna or burnt umber—and so will viridian.

Step 1. The most important colors on your watercolor palette are the primaries: the reds, yellows, and blues. These are the colors you can't do without. Every color on the color wheel can be made with some combination of primaries, but there's no way of mixing other colors to make a primary. To learn more about color mixing, try painting a picture with just the three primaries. This field of wildflowers is painted entirely with ultramarine blue, cadmium yellow, and cadmium red. The artist begins with a simple pencil drawing. Then he covers the shapes of the flowers with a masking liquid available at art supply stores. (Later on, you'll find out why.)

Step 2. Starting at the top of the picture, the artist paints the sky with ultramarine blue, warmed with a very slight touch of cadmium red, and diluted with various amounts of water. Obviously, there's less water in the darker areas and more water in the lighter strokes toward the horizon. When the sky is dry, he paints the dark shape of the mountain with ultramarine blue and a little cadmium red, barely diluted with any water. Notice how he carefully paints the dark tone of the hill around the intricate shapes of the fallen tree trunk and the two evergreens at the right.

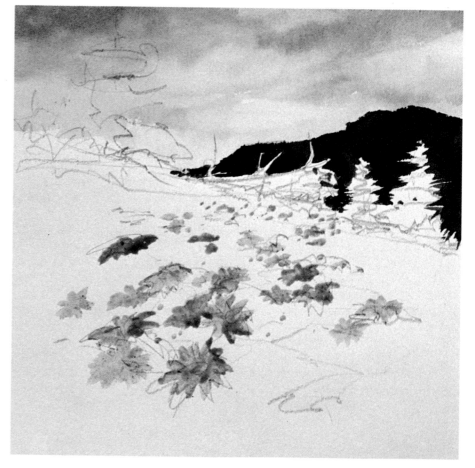

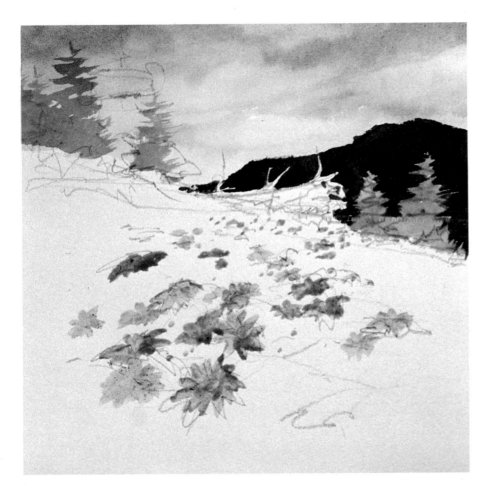

Step 3. When the dark hill is absolutely dry, the artist fills in the shapes of the two evergreens at the right with *almost* pure cadmium yellow, subdued very slightly by specks of both cadmium red and ultramarine blue. It's important to remember that the three primaries, mixed together, will produce a variety of muted colors in the brown-gray range. So a single bright primary can be softened by the slightest mixture of the other two. In the upper left, the artist does, in fact, mix all three primaries for the pale, neutral tones of the distant evergreens.

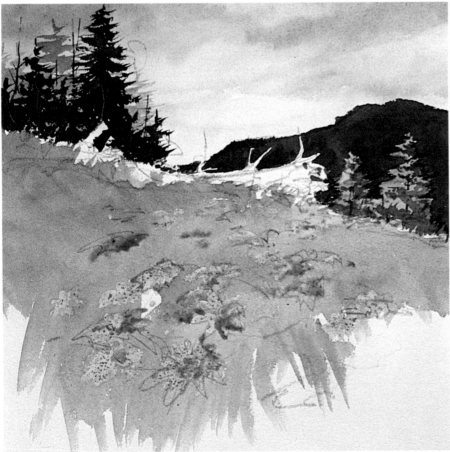

Step 4. When the pale evergreens are dry, the artist blends another dark mixture on his palette for the evergreens in the upper left. Ultramarine blue and cadmium yellow produce a deep, subdued green, which turns even darker when the artist adds a slight touch of cadmium red. He paints this strong dark right over the pale tone of the more remote evergreens. For the warm shadows on the sunstruck trees at the right, he again mixes the three primaries, this time adding less blue and more water for a lighter, more transparent tone. He covers the sunny grass of the foreground with a mixture that's mainly cadmium yellow, warmed with a touch of cadmium red, then subdued with just a hint of ultramarine blue.

Step 5. At the end of Step 4, the tree trunk on the horizon remains bare paper. Now the artist mixes a rich brown that's mainly cadmium red and cadmium yellow, darkened with a few drops of ultramarine blue. He brushes this color carefully along the underside of the tree trunk, leaving bare paper for the sunlit edges of the wood. Moving up from the bottom edge of the picture, he warms the foreground with that same mixture, lightened with more water. While the warm foreground mixture is still wet, he mixes a subdued, cool tone with ultramarine blue and cadmium yellow, brushing this across the middleground and allowing the cooler mixture to flow into the wet, warm color of the foreground.

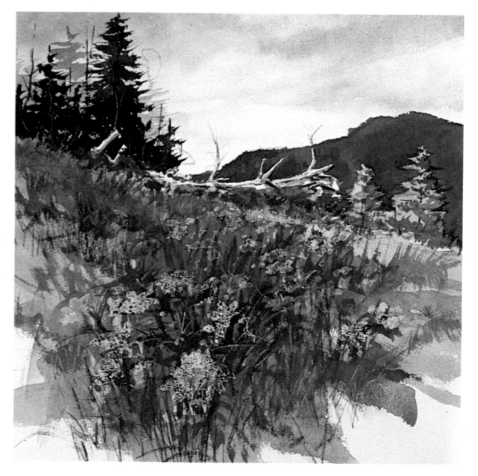

Step 6. After allowing the foreground colors to dry thoroughly, the artist creates two new mixtures on his palette, one warm and one cool. With ultramarine blue and cadmium yellow, plus a few drops of cadmium red, he mixes a dark, subdued green that he carries across the meadow with slender, erratic strokes to suggest blades of grass. The warm grass color is cadmium red and cadmium yellow, darkened with a touch of ultramarine blue. This mixture is loosely brushed across the foreground to warm the tone of the meadow.

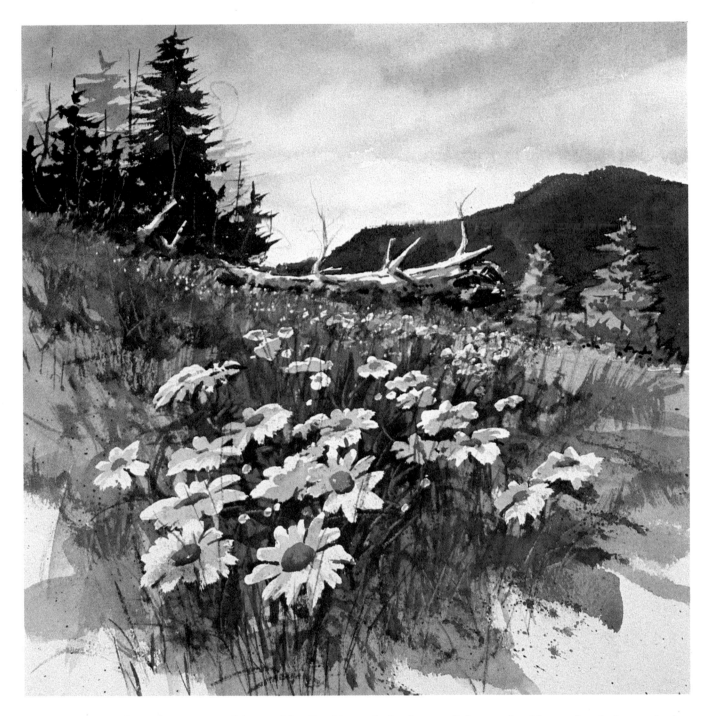

Step 7. Now you'll see the purpose of the masking liquid that covered the flowers in Step 1. The rubbery, water-resistant fluid dried and formed a protective skin over a part of the painting that was to be kept pure white. Now the "skin" peels off easily. When the artist removes the dried masking liquid from the flowers, their shapes are brilliant white paper. To paint the pale shadows on the petals, the artist mixes all three primaries to make a neutral tone, and then he dilutes this tone with plenty of water. He applies this tone sparingly to preserve the brilliant white of the petals. Then, at the center of each blossom, he places a bright mixture of cadmium red and cadmium yellow, softened by just the slightest hint of ultramarine blue. He completes the painting by creating a dark mixture of ultramarine blue and cadmium red, plus just a little cadmium yellow, for the strokes of strong shadow that he places on the tree trunk and beneath the flowers in the foreground. (The shadows beneath the flowers intensify the whiteness of the petals.) The fascinating thing about this picture is that almost every mixture contains the three primary colors—yet the mixtures are varied because the artist keeps changing the proportions of the three primaries. It's also interesting to see that these three rich colors can produce such subtle mixtures. There's no law that says that bright tube colors must produce bright mixtures. The artist can make the bright colors do whatever he wants them to do—as you'll see in the next demonstration.

Step 1. Before trying out the full range of colors on your watercolor palette in a *bright* picture, challenge yourself to paint a *subdued* picture with all those brilliant tube colors. This demonstration will show you how to use a full palette of colors to produce a subdued painting of a coastal landscape. The artist begins with the usual pencil drawing. Then he wets the sky with clear water, stopping at the headland and the horizon. On the wet, shiny paper, he brushes various mixtures of ultramarine blue and burnt sienna, some warmer and some cooler, depending upon the proportions of the colors in the mixture. The strokes fuse softly on the wet paper.

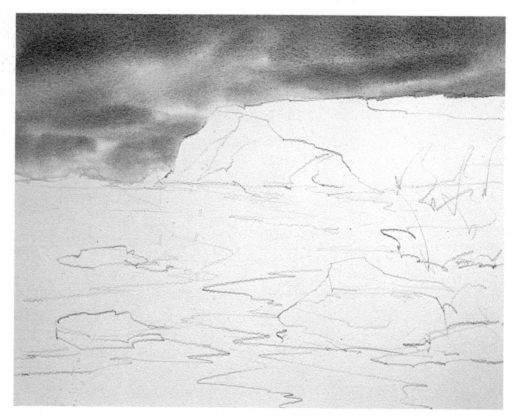

Step 2. The artist lets the sky dry thoroughly. (If you own an electric hair dryer, a blast of hot air will speed the drying process.) For the warm top of the headland, the artist mixes alizarin crimson, yellow ochre, and ultramarine blue. He adds more water for the paler area at the lower edge of the wash. The cooler side plane is painted with various blends of cerulean blue, yellow ochre, and burnt sienna. When the warm top plane of the headland is thoroughly dry, the artist adds a few darker strokes of viridian and alizarin crimson to suggest lines of distant trees. A few strokes of clear water blur the end of the headland to indicate foam breaking against the rocks.

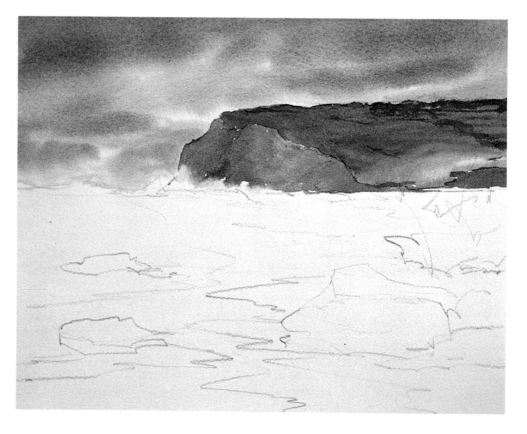

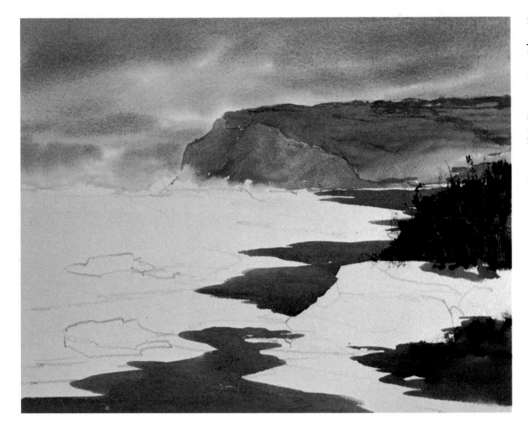

Step 3. For the warm, dark, jagged shapes of the beach, the artist combines three primaries on his palette: the bright, clear cerulean blue; the brilliant alizarin crimson; and the more subdued yellow ochre. The dark bushes at the right are painted with phthalocyanine blue, yellow ochre, and the slightest touch of cadmium red to produce the powerful, mysterious dark that you see here. While the color is still damp, he scratches away a few branches with the pointed end of his wooden brush handle.

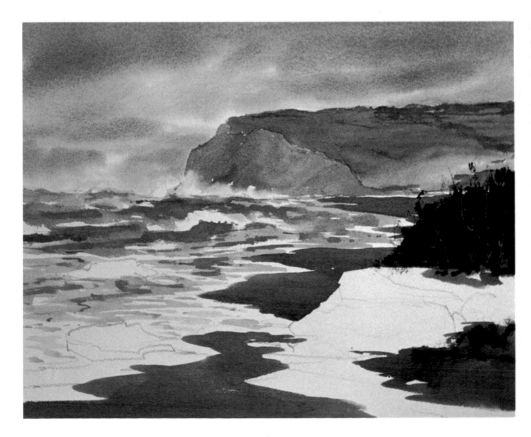

Step 4. On this moody, overcast day, the color of the waves is subdued, like the surrounding landscape. First, the artist paints the paler tones of the water with cerulean blue, new gamboge, a little burnt umber, and lots of water. Then, for the shadowy edges of the waves and the dark patches under the pale foam, he adds more cerulean blue and burnt sienna. The foaming tops of the waves—as well as the foam that spills up the beach—remain bare white paper.

Step 5. The dark rocks in the foreground are first covered with a flat wash of cerulean blue, burnt sienna, and new gamboge. When this mixture dries, the artist blends a rich dark—phthalocyanine blue and burnt umber—to paint the shadows and cracks in the rocks. Across the sand in the foreground, the artist washes a soft, cool mixture of ultramarine blue, alizarin crimson, and burnt sienna to unify the color of the beach. With a darker, warmer version of this mixture—less water and more burnt sienna—he darkens the edge of the beach and adds the reflection beneath the big rock in the lower left.

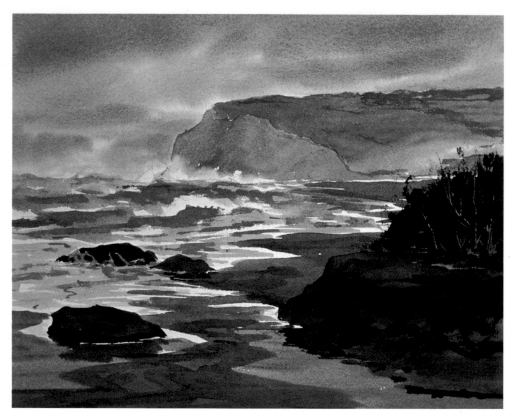

Step 6. The artist begins to build up the detail in the foreground with small, dark strokes. He uses the sharp point of a small brush to place crisp, dark touches of phthalocyanine blue and burnt umber on the rock formation in the lower right, to add two more dark rocks to the edge of the beach—one in the foreground and one in the middle of the picture—and to add other inconspicuous details like the reflection in the lower right corner and the tiny touches of darkness that suggest pebbles, seaweed, and other coastal debris at the water's edge.

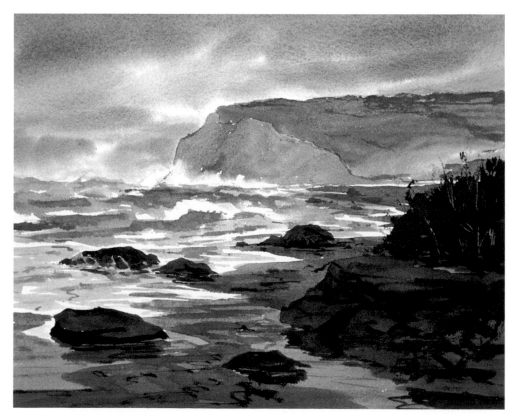

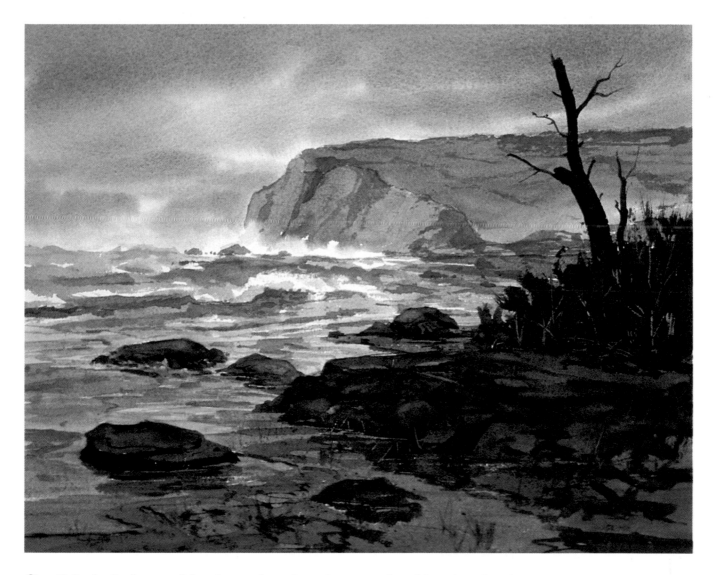

Step 7. In the final stage of the picture, the artist makes an important change. He decides to strengthen and simplify his composition by extending the rocky foreground from the right-hand corner into the center of the picture. For this dark shape, he uses the same mixtures he's already used in Steps 5 and 6. He also decides to darken and unify the tone of the beach by carrying a cool wash across the sand in the immediate foreground. This is a mixture of cerulean blue, alizarin crimson, and burnt sienna. Now the entire foreground seems cool, wet, more shadowy, and more luminous. To strengthen the contrast between the dark foreground and the paler headland in the distance, the artist places the sharp silhouette of a broken tree in the upper right with a mysterious dark mixture of phthalocyanine blue and burnt sienna. With this same mixture, he adds strong shadows to the lower edge of the foreground rock formation, more reflections in the wet beach, and small, scattered strokes that suggest additional shoreline debris in the lower left. Moving into the middleground, he scrubs the tops of the rocks with a wet bristle brush and then blots away some of the wet color with a cleansing tissue. Now the rocks seem wet, and their wet surfaces appear to reflect the light in the sky. Mixing cerulean blue, burnt umber, and yellow ochre, the artist creates a shadowy tone that he places selectively on the side of the distant headland. Now you have a clear sense of lights and shadows on the side plane of that massive rock formation. With ultramarine blue, yellow ochre, and a little burnt umber, the artist adds more darks to the waves, strengthening their shapes and creating stronger contrasts between the lights and darks in the water. Beneath the foam of the breaking wave at the center of the picture, he adds a few touches of shadow with cerulean blue, burnt umber, and plenty of water to make sure that the shadow isn't *too* dark. Finally, he adds a few strokes of beach grass with a pointed brush, and scratches some light lines into the shadowy foreground with the sharp corner of a razor blade. The finished picture is subdued, but full of color. Many of the brightest colors on the palette have been combined to produce all these muted tones, which turn out to be surprisingly rich when you look at them closely.

Step 1. Painting a colorful landscape in bright sunlight will give you an opportunity to learn more about the range of color mixtures you can produce with your full palette. But remember, bright color doesn't mean *garish* color! You'll also have to learn how to subdue each brilliant mixture just enough to prevent its leaping out of the picture. After sketching the composition, the artist begins this tropical landscape by painting the sky a brilliant phthalocyanine blue. To make that stunning blue hold its place in the distant sky, he softens the pure color with a touch of burnt umber. For the shadows on the clouds, he adds more burnt umber and a speck of alizarin crimson.

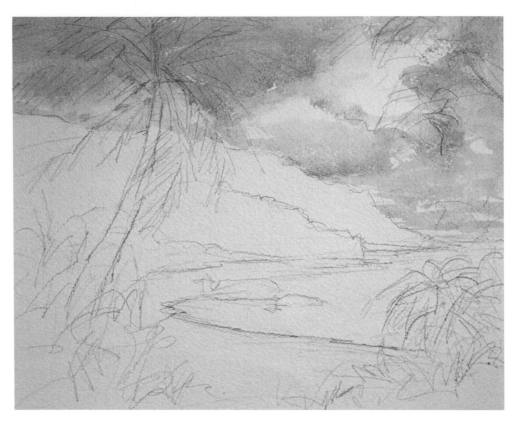

Step 2. For the tone of the distant mountain, the artist again mixes two brilliant colors on his palette: phthalocyanine blue and alizarin crimson. Then, to keep the mountain far back in the picture, he adds a speck of burnt umber and plenty of water. When this wash is dry, he paints the nearer, tree-covered slope with small strokes that flow softly together: ultramarine blue and cadmium yellow for the cooler tones; new gamboge, alizarin crimson, and a hint of ultramarine blue for the warmer tones. When the slope is dry, the artist paints the low, shadowy cluster of foliage with ultramarine blue, alizarin crimson, and yellow ochre.

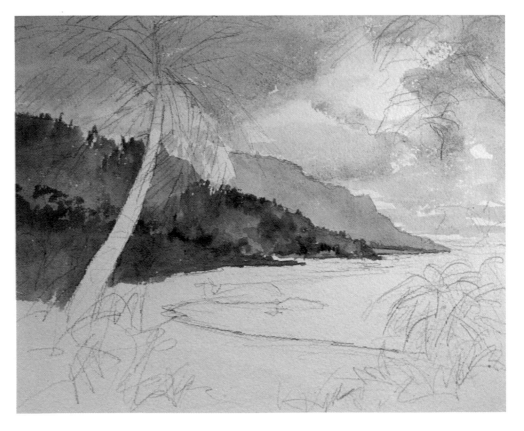

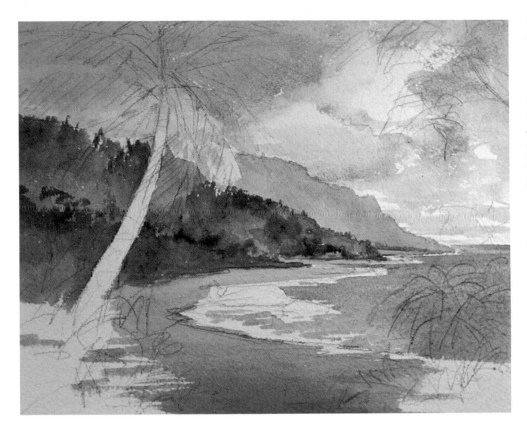

Step 3. The water is painted with a mixture of phthalocyanine blue—the same brilliant blue that's used in the sky—softened with yellow ochre and a touch of burnt umber, plus plenty of water, since a little phthalocyanine blue goes a long way. Note that the water isn't painted to the edge of the sand, but stops just short of the beach so that the bare paper suggests foam. Then the artist carefully blocks in the curving shape of the beach with yellow ochre and burnt umber, adding less water in the foreground and more water as the beach winds around into the middle distance.

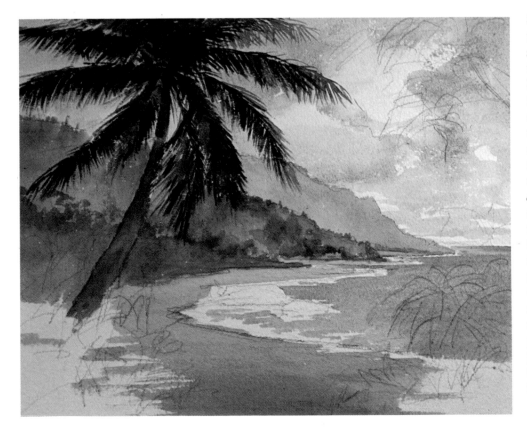

Step 4. When the sky, distant mountain, and wooded slopes are absolutely dry, the artist begins work on the big palm tree. First he paints the warm tone of the trunk and the warmer foliage—which you can see under the darker foliage—with ultramarine blue and cadmium orange. He uses a medium-sized, round brush for the trunk and then switches to a smaller, sharply pointed brush for the foliage. When this warm tone is dry, he mixes a darker, cooler tone with phthalocyanine blue, new gamboge, and burnt umber. Then, with the sharp point of the small brush, he paints this dark mixture over the warm undertone of the foliage.

Step 5. Now the artist covers the lower edge of the picture with a greenish mixture of ultramarine blue and new gamboge, warmed with alizarin crimson. He works upward, carrying this mixture over the beach and water with slender, curved strokes that suggest tropical grass, silhouetted against the sunny sand and water. At the left of the palm tree, he adds a few strokes of dark, cool foliage with the same mixture he's used for the dark foliage of the palm in Step 4. These dark strokes blur softly into the wet color of the beach grass at the foot of the tree. Strokes of phthalocyanine blue and burnt sienna suggest shadows and textures on the trunk of the big palm.

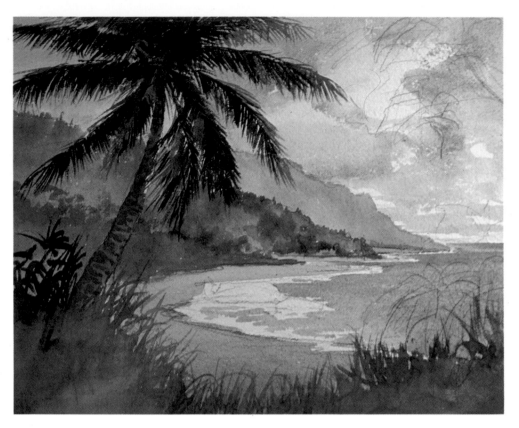

Step 6. When the warm foreground tone is dry, the artist blends phthalocyanine blue, yellow ochre, and burnt sienna on his palette to produce a dark, shadowy mixture. Slender, curving strokes of this mixture are built up over the dark undertone of the foreground to suggest dense tropical growth. At the right, the artist adds a cluster of tropical plants with this mixture. Notice how he adds more water for the paler foliage at the top. Just under the big palm, the artist places a few spots of cadmium red, softened with a speck of burnt umber, to indicate tropical flowers along the beach.

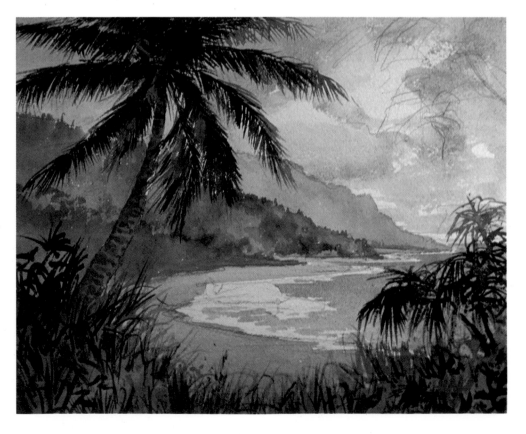

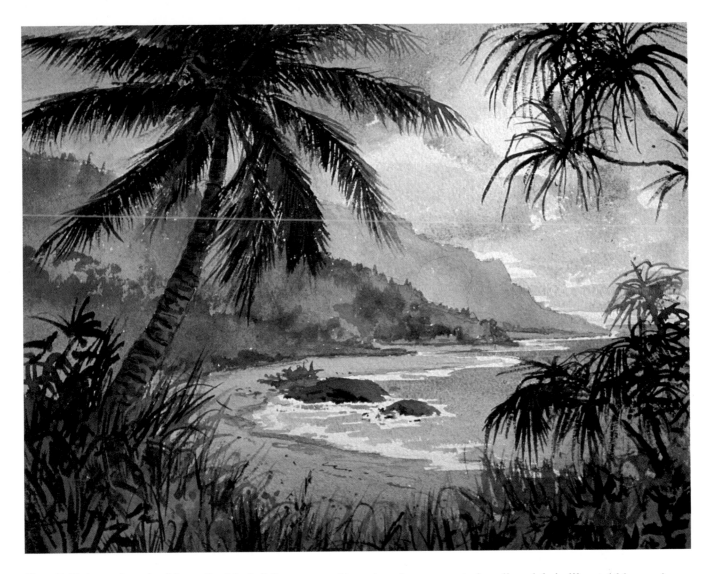

Step 7. To complete the "frame" of dark foliage around the sunny beach, the artist adds more branches in the upper right corner. These are painted in the same way as the beach grass in the foreground. The artist starts with a paler, warmer mixture of ultramarine blue, cadmium yellow, and burnt sienna, lightening this tone with water. When these first strokes are dry, he completes the branches with a darker, cooler mixture of phthalocyanine blue, new gamboge, and burnt sienna. With this same dark mixture, he thickens the shadowy foliage of the big palm and adds more dark strokes to accentuate the texture and detail of the trunk. The dark shapes of the rocks in the water are finally painted with ultramarine blue, new gamboge, and a little cadmium red—with more ultramarine blue for the small strokes of shadow. The artist dilutes this mixture with water to strengthen the edge of the beach where it meets the ocean. Tiny strokes and dots of the rock mixture are scattered along the beach to suggest shoreline debris like pebbles and seaweed. A few more wildflowers are added among the foreground foliage with cadmium red and a slight touch of burnt umber. If you study the final painting, you'll make an interesting discovery. The artist has used the full range of brilliant colors on his palette to capture a sunny tropical shore—but his mixtures are much more subtle than you might expect. The brilliant tube colors have been carefully softened so that they hold their place in the picture and don't compete with one another. The strong contrasts of sunlight and shadow, typical of the tropics, have been created mainly by differences in value, rather than by brilliant color. The pale tones of the beach, the sea, and the wooded slope look sunny not only because the artist has chosen the right color mixtures, but because these paler tones are surrounded by the strong darks of the palm and the tropical growth in the foreground.

Step 1. The first four demonstrations have shown the *direct* technique, where each color is mixed separately on the palette and applied directly to the paper in a single operation. But in the eighteenth and nineteenth centuries, the British Old Masters of watercolor perfected a different method, one that starts with a monochrome underpainting. To demonstrate that technique, the artist begins with a precise pencil drawing that defines the light and shadow planes. He then mixes a warm, neutral tone with burnt umber and ultramarine blue, plus plenty of water. This tone is then brushed over everything except the lightest planes, and is left to dry. Now we have the lights (the white paper) and the pale middletones.

Step 2. The artist locates the darker middletones. He covers these areas with a second wash of the same mixture he's used in Step 1. Because these areas now contain two separate washes, they're twice as dark as the tone that covers the paper in the first step. When the second wash is absolutely dry, he then locates the darks and blocks in these areas with a third wash that's identical in tone to the first two washes—or perhaps just a bit darker. When the third wash is dry, the artist has a complete rendering of the pattern of light and shade on his subject in four values: light, two middletones, and dark.

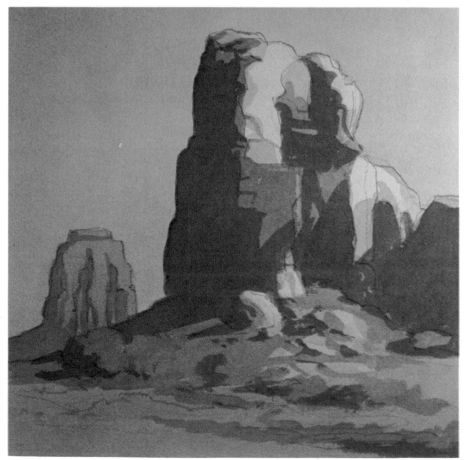

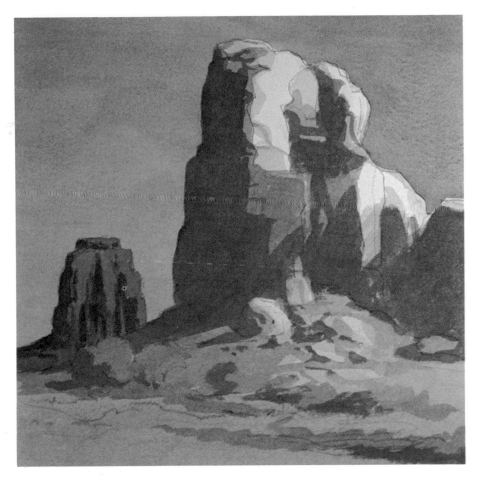

Step 3. By the end of Step 2, the artist has established the forms and has indicated light and shade. Now he can concentrate primarily on color. He washes pure ultramarine blue over the sky, carrying this cool mixture over the rocky shadow shapes to cover just the darks and the darker middletones. This cool wash also covers the distant rock formation at the left. When the blue wash is dry, he runs a warm wash of cadmium red, burnt sienna, and yellow ochre over the distant rock formation. He reinforces the shadows with ultramarine blue and alizarin crimson. The artist works with washes of bright, clear color because these mixtures become more subdued as they travel over the monochrome underpainting.

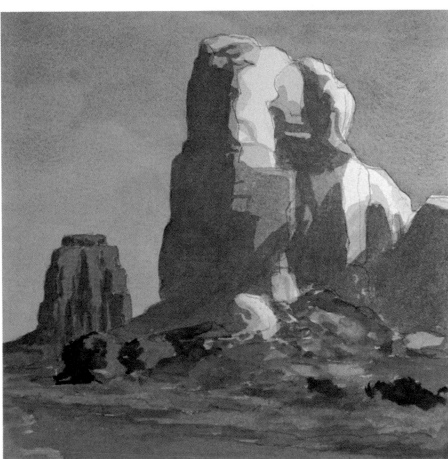

Step 4. The artist begins to warm the foreground with a pale wash of new gamboge and cadmium red. When this golden tone dries, he enriches parts of the foreground with a stronger, brighter version of the same mixture, containing more cadmium red and a touch of burnt sienna. On the dried washes that cover the foreground, the artist begins to suggest some desert plants with dark patches of ultramarine blue and cadmium orange.

Step 5. The artist carries the warm foreground tone—new gamboge, cadmium red, and burnt sienna—up over the big rock formation with rough, irregular strokes that suggest the texture of the rocks. This tone immediately warms the lights, middletones, and darks on the rock. In the foreground, the artist develops the desert growth with a series of pale strokes of ultramarine blue and cadmium orange. When these strokes are dry, he adds darker strokes of the same mixture.

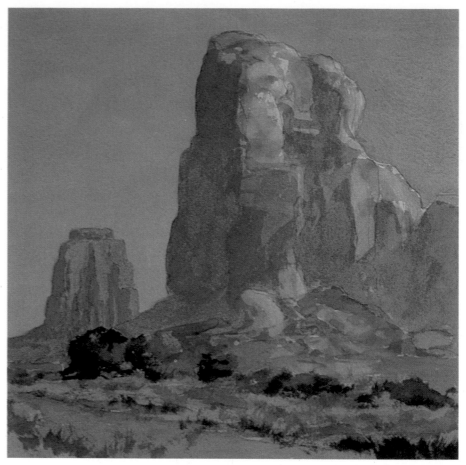

Step 6. Mixing a dark wash of ultramarine blue and burnt sienna on his palette, the artist deepens the shadows on the big rock formation and on the slope, with bold, decisive strokes. Smaller strokes of this same dark mixture are used to suggest cracks in the rocks, and to indicate boulders on the ground. A few more touches of warm color are added to the lighted planes of the massive rock formation with new gamboge, cadmium red, and burnt sienna. The color of the slope at the foot of the rock is also intensified by a few strokes of this mixture.

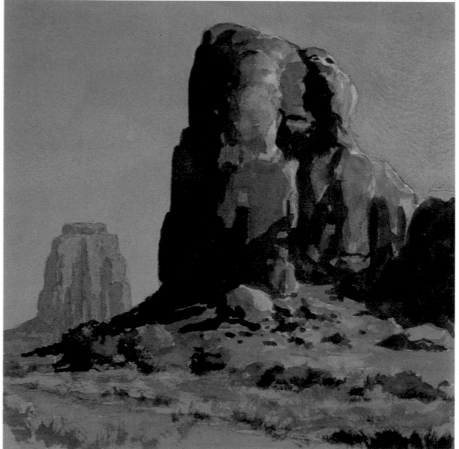

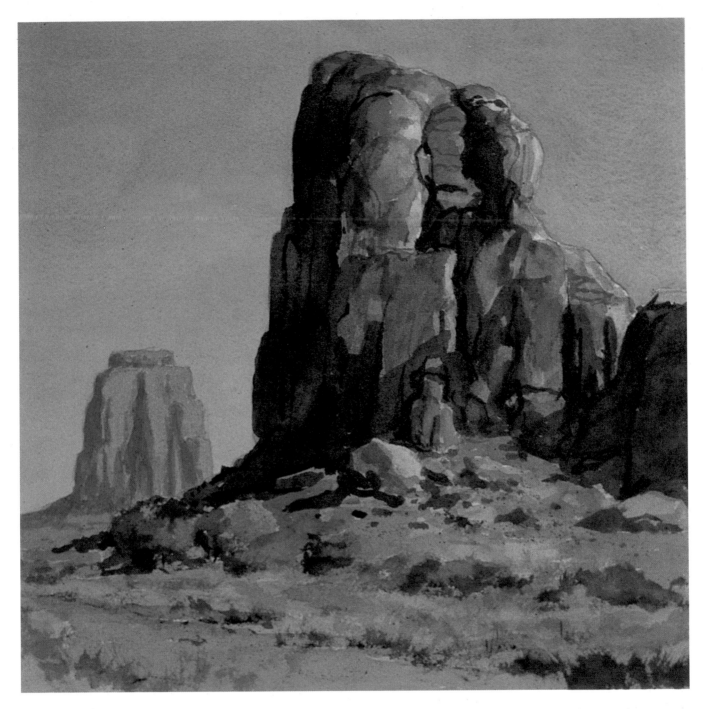

Step 7. With a dark mixture of ultramarine blue and burnt sienna, the artist adds more cracks and other details within the big rock formation. These slender strokes appear not only in the lighted areas, but also within the shadows. He cools some of the middletones in the rocks with a pale wash of ultramarine blue. He suggests more boulders and pebbles with tiny, dark touches of ultramarine blue and burnt sienna. He spatters some of these dark flecks onto the paper with a wet brush that's shaken over the surface. With this mixture, he strengthens the shadows beneath the desert plants in the foreground. At the last minute the artist decides that the ragged strip of desert plants needs to be cooler, so he brushes them with a pale wash of ultramarine blue and new gamboge. The shadows of the distant rock formation are accented with darker strokes of ultramarine blue, alizarin crimson, and burnt sienna. Looking back over this demonstration, you can see the logic of this classic technique. The painting is built up in gradual stages, wash over wash. First, the artist builds up the forms by working gradually from light to dark. When the pattern of light and dark is completed, the artist builds up the color in a series of washes, each more intense than the wash before. The final watercolor has a particularly strong, three-dimensional feeling because of the monochrome underpainting. In contrast with the direct technique, this method of painting a watercolor depends primarily on optical, rather than physical, mixtures.

Step 1. When you work with a monochrome underpainting, your optical mixtures are always a bit subdued. To discover how to create brighter optical mixtures, try underpainting in color. In this demonstration, the artist works with just three color mixtures to create a limited-color underpainting. He draws the rocks, tide pools, headland, and horizon carefully so that he has a clear idea of where each underpainting color will go. Then he brushes a wash of yellow ochre over the sky and the tide pools, leaving gaps in the sky to suggest clouds. This first underpainting wash is allowed to dry.

Step 2. The headland at the left is blocked in with a wash of alizarin crimson and just a hint of ultramarine blue. Then the artist covers the two big rock formations, the patches of beach between the tide pools, and the strip of receding beach with pure ultramarine blue—adding much more water for the distant beach. Thus, the forms in the foreground are darkest, obeying the "laws" of aerial perspective even in this simple underpainting.

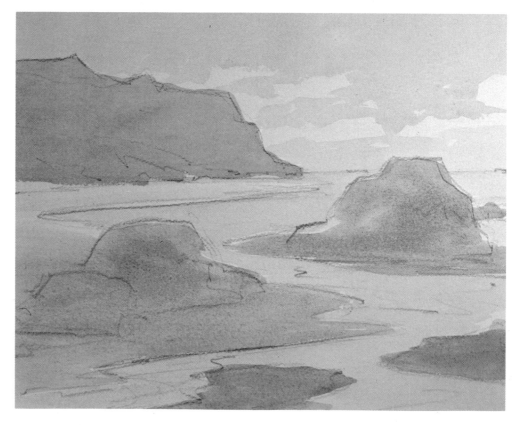

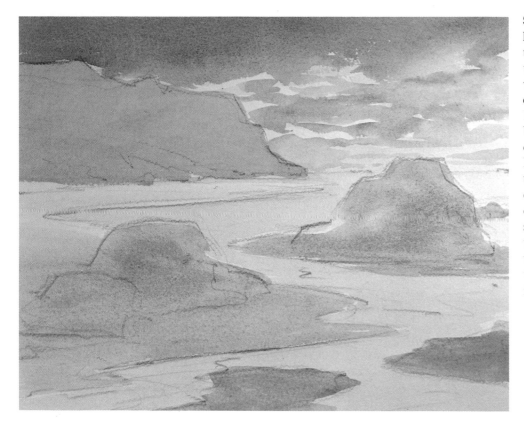

Step 3. Over the warm yellow ochre underpainting of the sky, the artist brushes ultramarine blue, modified with just a hint of alizarin crimson and burnt umber. He adds more water to his brushstrokes as he works down toward the horizon. He also leaves gaps between the strokes, allowing patches of white paper and yellow ochre underpainting to shine through. Thus, we see the scattered clouds above the horizon, and a suggestion of warm sunshine glowing throughout the sky.

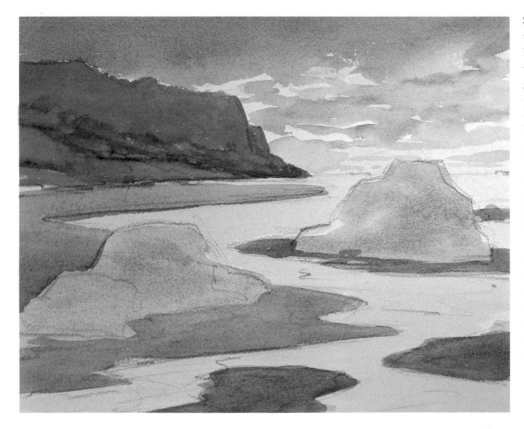

Step 4. Over the top half of the headland, the artist brushes ultramarine blue, which is warmed by the alizarin crimson underpainting. Along the lower part of the cliff, the artist brushes strokes of burnt sienna, which forms a luminous optical mixture with the alizarin crimson underpainting. The artist washes a paler burnt sienna tone over the beach beneath the cliff. He carries this wash around to the foreground sand. In the distance, the beach looks sunnier because the blue underpainting is paler, while the sand in the foreground looks shadowy because the cool underpainting is darker.

Step 5. Over the ultramarine blue underpainting of the foreground rocks, the artist brushes broad strokes of burnt sienna and cadmium red. This brilliant mixture is cooled and softened as it forms an optical mixture with the underpainting. (The artist purposely leaves a few gaps between his strokes on the rocks.) When the rocks are dry, the artist carries a pale wash of cerulean blue over the yellow ochre underpainting of the water. Notice how he again leaves gaps in his strokes to let the sunny tone of the yellow ochre underpainting come through. To suggest sunlight on the water at the horizon, he leaves the warm underpainting untouched.

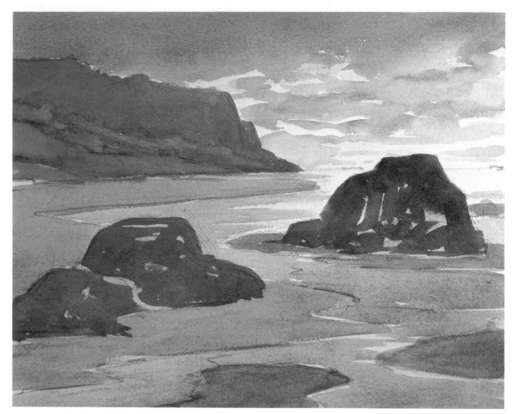

Step 6. Working with straight strokes to accentuate the blocky shapes, the artist paints the shadows on the rocks with ultramarine blue—forming a dark, optical mixture with the warm, underlying tone of Step 5. Where the underlying burnt sienna tone remains untouched, we see sunlit planes on the rocks. The artist mixes burnt sienna and ultramarine blue, and brushes this into the tide pools to indicate the reflections. To darken the shadowed patches of sand in the foreground, the artist blends ultramarine blue, alizarin crimson, and a little burnt sienna, which he brushes across the sand in long, horizontal strokes.

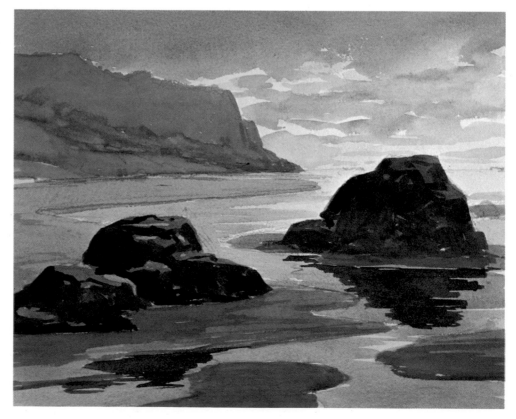

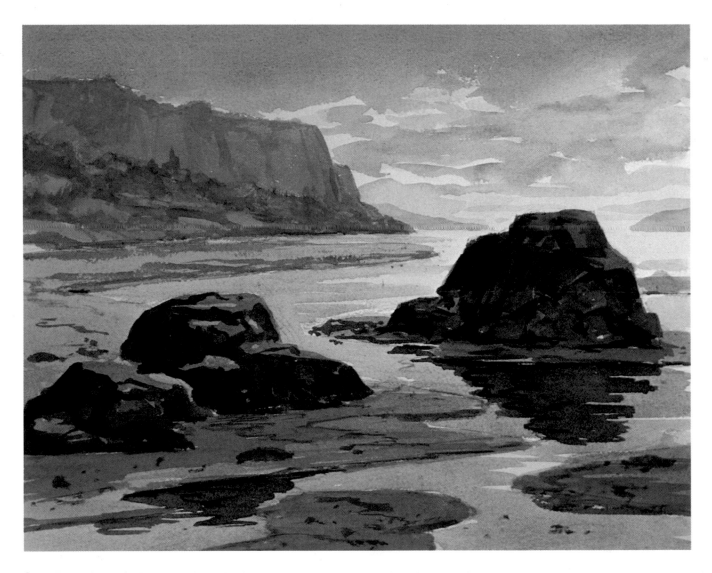

Step 7. By the end of Step 6, virtually the entire painting has been covered with optical mixtures. Now the artist can concentrate on details. With ultramarine blue, alizarin crimson, and burnt sienna, he paints the shadows and the crevices on the face of the distant headland. These strokes form a new optical mixture with the underlying color. The foliage on the warm slope at the foot of the headland is added with small strokes of ultramarine blue and cadmium yellow—warmed and subdued by the underlying tone. The shape of the distant strip of beach is strengthened with slender, horizontal strokes of the same mixture that's used to paint the shadows on the cliff. To paint the cracks within the shadows on the foreground rocks, and to add darker strokes to the reflections in the tide pools, the artist mixes a particularly powerful dark with phthalocyanine blue and burnt sienna. Small dots and dashes of this dark mixture are scattered over the sand in the foreground to suggest pebbles. The artist also strengthens the edges of the sandy patches with dark strokes of this mixture. As you look at the finished painting, it's worthwhile to go back and analyze each optical mixture. Every area of the painting—except for the pale patches above and below the horizon—contains at least two separate washes that mix in the viewer's eye. And many areas—such as the sunny slope at the foot of the headland, the foreground rocks, and the patches of sand between the tide pools—contain three separate washes, plus additional strokes for detail. Like the watercolors of the British Old Masters, the picture is gradually built up, wash over wash. But it's underpainted in *color*, rather than in monochrome.

Step 1. Now that you've had experience building a watercolor over a monochrome underpainting and a limited color underpainting, you'll enjoy working with an underpainting in full color. This can be a splashy, spontaneous way of working. The artist begins with a loose pencil drawing, indicating the trees, mountain, and stream quickly and simply. Then he brushes a rough, irregular wash of cerulean blue over the distant mountain, stopping at the trees and letting his brushstrokes show. When the cool underpainting of the mountain is dry, he paints a strip of new gamboge, softened with yellow ochre, over the distant shore.

Step 2. Above the warm strip of the distant shore, the artist brushes in short, irregular strokes of ultramarine blue and a little alizarin crimson to underpaint the dark trees. On either side of this cool, dark underpainting, he brushes new gamboge and a little burnt umber to underpaint the big masses of foliage. He uses this same warm mixture to underpaint the shore in the foreground, carrying the warm tone into the water to suggest reflected color. While the water area is still wet, he brushes in a strip of cerulean blue; the two wet colors fuse softly. The artist underpaints the foliage in the lower left with a warm wash of ultramarine blue and alizarin crimson.

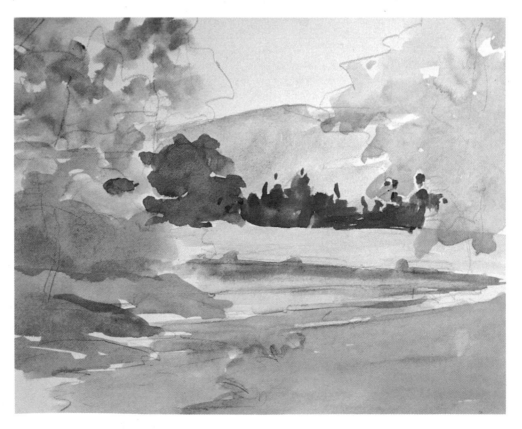

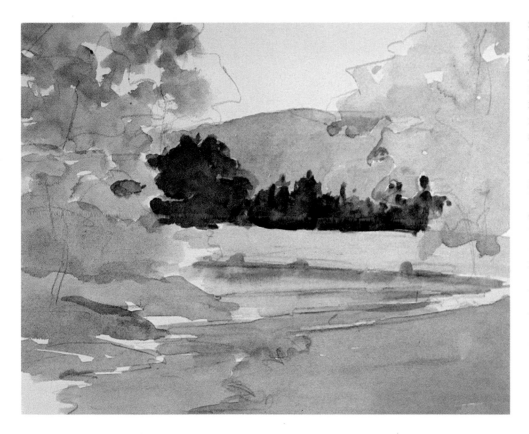

Step 3. The artist runs a pale wash of alizarin crimson over the cool underpainting of the distant mountains. The two washes merge to form an optical mixture that's warmer, but still remote. When the mountain is dry, the artist brushes rough strokes of new gamboge and a little burnt sienna over the dark, cool underpainting of the trees on the far shore. He adds just a touch of cadmium orange to the mixture for the big, dark tree in the background. Both the cool and warm overpaintings merge to form a dark, warm, optical mixture that seems to contain cooler shadows.

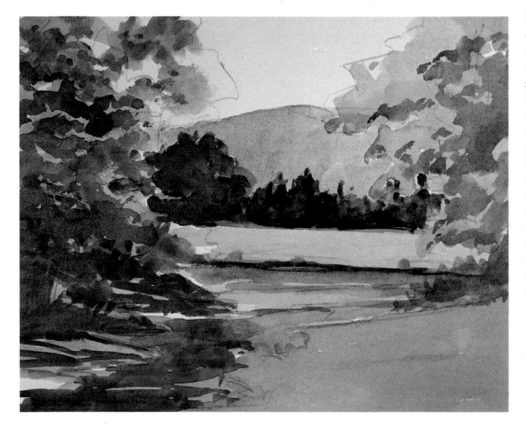

Step 4. The complex form of the tree at the extreme left is overpainted with irregular strokes of alizarin crimson, softened by ultramarine blue and burnt sienna. This dark mixture is carried down into the water to suggest the reflection of the tree. The mixture is deepened and subdued with a little more ultramarine blue and diluted with more water to overpaint the distant trees. Diluted with still more water, this warm mixture is carried into the stream—to form optical mixtures with the tones that are already there. The shadowed leaves on the right-hand tree and its dark base are defined with alizarin crimson.

Step 5. In the lower left, the artist builds up the shadows in the foliage—and the reflections in the stream—with dots and dashes of burnt sienna and ultramarine blue. Along the sunny shore beyond the stream, bushes are added with ultramarine blue and cadmium orange—repeated in the water to indicate reflections. The artist begins to develop the grass in the lower right with short, scrubby strokes of pale cerulean blue, followed by pale, warm strokes of alizarin crimson and burnt sienna. A few strokes of this warm mixture suggest pale middletones on the tree at the right.

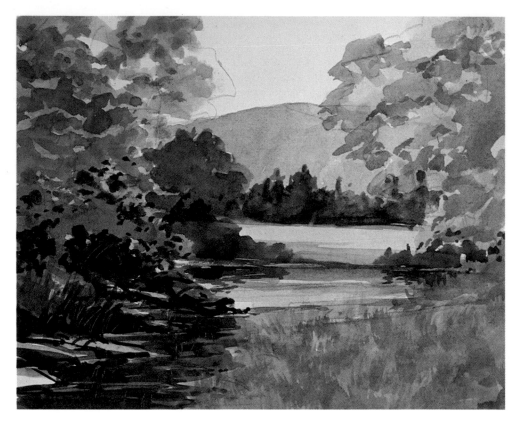

Step 6. Cerulean blue is brushed over the sky, stopping short of the mountain to let the undertone come through. The artist darkens the bushes on the far shore and their reflections with ultramarine blue and burnt sienna. The stream is cooled with pale cerulean blue that's carried down into the left-hand corner. The artist darkens this corner with ultramarine blue and burnt sienna, and then scrubs out the flat rocks with a wet bristle brush. He warms the big trees at either side, plus the grassy field in the foreground, with alizarin crimson softened with ultramarine blue and burnt sienna. Then he scratches weeds out of the wet color with the brush handle.

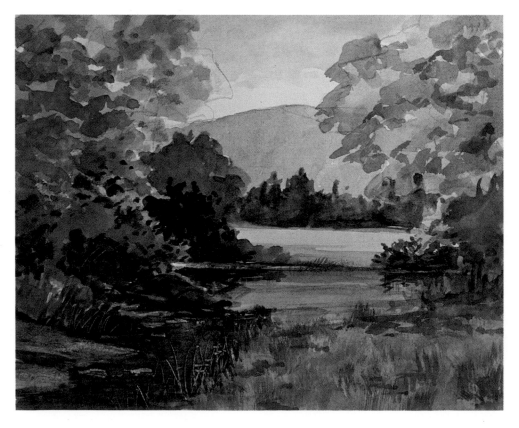

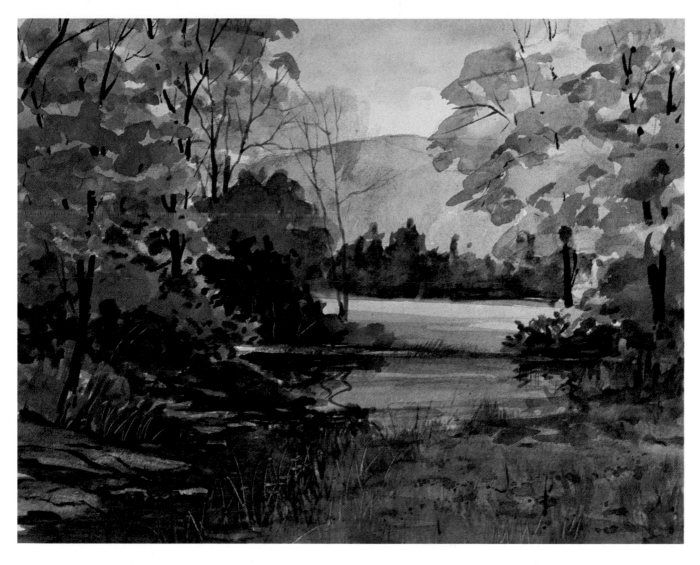

Step 7. Mixing a rich dark of viridian and burnt sienna, the artist places trunks and branches within the foliage at either side of the picture. These trunks and branches are painted with short strokes, interrupted by the clusters of leaves. He adds one more tree on the far shore with slender strokes of ultramarine blue and cadmium orange. This is diluted with lots of water to make a few broad, scrubby strokes that indicate foliage at the top. He then strengthens the foliage in the upper left with strokes of burnt sienna and alizarin crimson, subdued by a hint of viridian. He builds up the detail of the grass in the foreground with this same mixture. But he decides that the foreground is becoming too warm. So he tones down the grassy field with a pale wash of cerulean blue that mixes with the warm undertone to create a particularly fascinating, shadowy optical mixture. Where the wet bristle brush has scrubbed out the shapes of the rocks in the lower left, the artist delineates the cracks on these flat rocks with strokes of ultramarine blue and burnt sienna. To suggest the cool tone of the water running over these rocks, he tints them with the palest possible wash of ceru-

lean blue. The finishing touches are a few more dark strokes for the wiggly reflection of the slender tree in the water, and more pale scratches to indicate foreground weeds and branches among the bushes on the far shore. Comparing the completed painting with the underpainting in Step 2, you may be surprised to see how those splashes of pure color have been transformed into subtle optical mixtures. Every area of the painting contains at least two washes of color: the underpainting and at least one overpainting. But *most* of the picture contains three or more layers of transparent color that blend in the viewer's eye to create complex and magical optical mixtures. This method of building up a watercolor—in a series of washes—is ideal for capturing the subtleties of light and atmosphere. The complex shadow tone in the lower right, for example, would be impossible to duplicate by the direct technique. So would the stream in the center of the picture, and the trees at the left, where multiple colors shine through one another to produce optical mixtures that defy description.

Step 1. Still another way to paint a watercolor is to exploit the texture of the paper when you apply liquid color—and when you remove that color. A sheet of rough paper has a pronounced *tooth* that's ideal for textural painting techniques, as demonstrated here. The artist chooses rocks, a fallen tree, and white water as subjects that are particularly suitable for this painting method. He begins by painting the sky with a smooth wash of phthalocyanine blue, softened with burnt umber and a little yellow ochre. He then adds the mountains with ultramarine blue, burnt sienna, and a few drops of alizarin crimson, and the warm tone of the distant trees with cadmium orange and a bit of ultramarine blue.

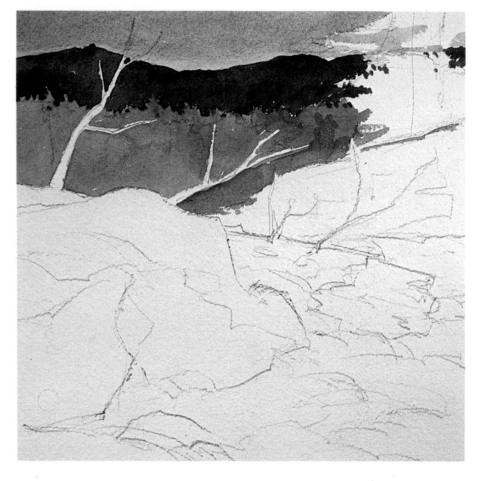

Step 2. In the upper right-hand corner, the artist underpaints the big, dark tree with burnt sienna, a touch of cadmium red, and ultramarine blue. When this warm tone is dry, he brushes in the dark branches of the tree with phthalocyanine blue and burnt sienna. Moving to the left, he paints the smaller evergreens in exactly the same way, beginning with the paler, warmer mixture for the more distant trees, letting these washes dry, and then overpainting them with the darker mixture to render the nearer trees. Notice how he uses the pointed wooden handle of the brush to scratch a few lines into the wet color, indicating tree trunks. In Steps 1 and 2, the artist works carefully around the branches of the dead tree, which remain bare white paper.

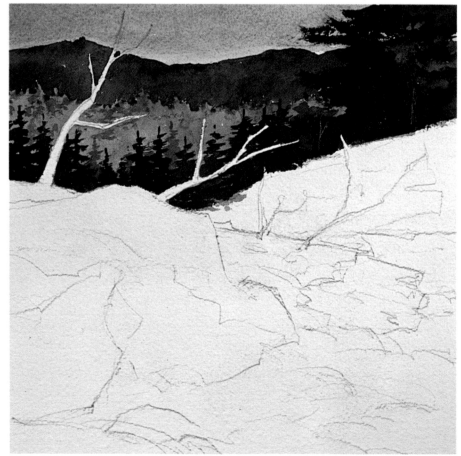

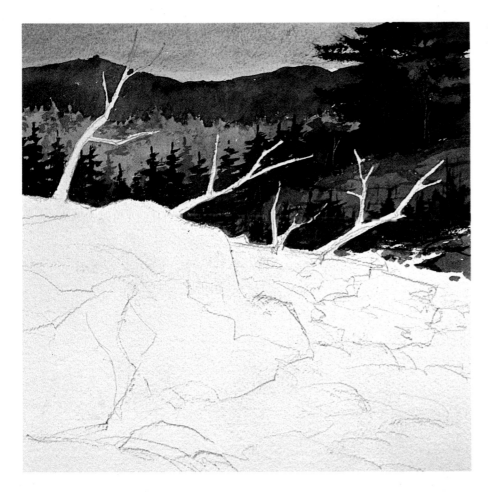

Step 3. The artist completes the dark background by extending the landscape down to the water's edge at the right. First he brushes in a flat wash of burnt sienna with a little ultramarine blue, tracing the brush carefully around the silhouetted shapes of the sunlit branches. When this tone is dry, he adds more ultramarine blue—and less water—to paint the warm shadow beneath the big tree in the upper right-hand corner. Now he paints the dark evergreens along the shore with the familiar mixture of phthalocyanine blue and burnt sienna.

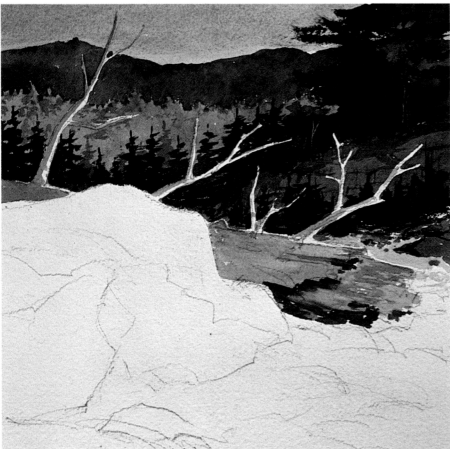

Step 4. Beginning work on the foreground, the artist paints a warm tone at the broken end of the tree with a pale wash of burnt umber, yellow ochre, and a little ultramarine blue. While the wash is still damp, he adds darker strokes of burnt umber and ultramarine blue to indicate the shadow edges, which melt softly away into the pale, wet color. The cooler tone of the bark is painted with the same three colors, but in different proportions: more ultramarine blue, less burnt umber and yellow ochre. He adds a crack in the bark with burnt umber and ultramarine blue, repeating this mixture on the broken end of the tree. The artist carefully leaves slender strips of bare paper along the sunlit edges of the shapes.

Step 5. Now the textural painting begins. Turning a flat brush on its side and gliding lightly over the painting surface, the artist blocks in the tone of the rocks with erratic strokes that are broken up by the tooth of the rough paper. The rock tone is burnt umber, ultramarine blue, and yellow ochre, diluted with varying amounts of water. To enhance the rough texture, the artist blots parts of the rock with a crumpled paper towel. Picking up a darker version of the same mixture on a small brush, the artist draws the cracks in the fallen tree. The brush is damp, not wet, and the texture of the paper roughens the strokes. The corner of a razor blade, skipping lightly over the painting surface, creates ragged strips of light on the bark.

Step 6. Again working with the side of a big, flat brush, the artist blocks in the dark shadows on the rocks with burnt sienna, yellow ochre, and ultramarine blue. He moves the brush lightly over the paper so that the rough texture of the painting surface breaks up the strokes. He blots away some of the shadow tones with a rough, crumpled paper towel. When the shadow tones are dry, he spatters the rocks with droplets of ultramarine blue and burnt umber, shaken from a wet brush. After waiting for the rocks to dry thoroughly, he scrapes away the lights with the flat edge of a razor blade, moving it gently across the paper.

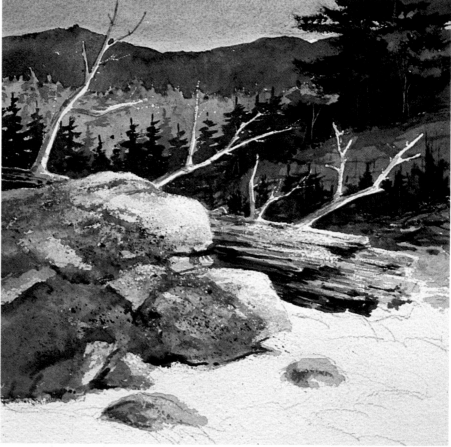

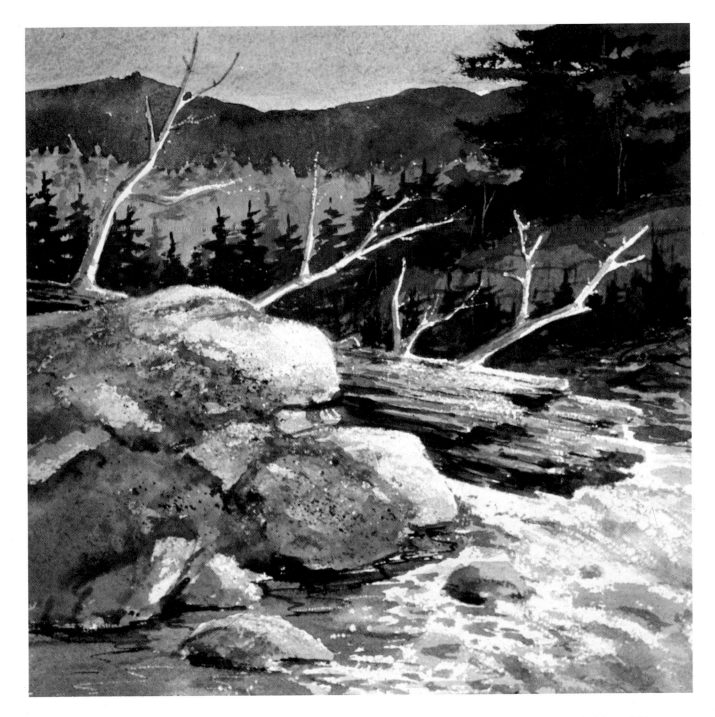

Step 7. By holding the side of the damp brush against the rough paper to make a ragged stroke that's broken up by the texture of the painting surface, the artist paints the water with strokes that follow the movement of the stream. These drybrush strokes are applied with light movements that allow flecks of bare paper to show through, suggesting the white water. When the water is absolutely dry, he uses the flat edge of a razor blade to scrape away more patches of white. (The artist doesn't dig the blade into the paper, but gently shaves away the high points of the irregular painting surface.) He drybrushes more color over the shadow sides of the rocks, allows the color to dry, and scrapes the lights again. The water, like the rocks, is essentially ultramarine blue, burnt umber, and yellow ochre—cooled by adding more blue. As you examine the finished painting, you can see that its entire lower half—the rocks, fallen tree trunk, and water—has been executed by drybrushing and scraping. The granular surface of the sheet breaks up the brushstrokes to suggest the grain of the rocks, the ragged character of the fallen tree, and the sparkle of the foam on the water. When the razor blade is carried gently across the rough paper, the sharp blade strikes only the high points of the painting surface, removing tiny granules of paper to reveal flecks of white. The secret of textural painting is not only knowing how to apply color, but knowing how to remove it!

Step 1. There are many ways to mix color. In the direct technique, you mix colors on the palette. In the various underpainting and overpainting techniques, you mix colors on your palette and then mix them again, in a sense, when you apply one wash over another. As you'll now see, there's still another way to mix colors—by doing it directly on wet paper. Completing the pencil drawing, the artist sponges the entire sheet with clear water. To suggest sunlight seen through the forest, he brushes yellow ochre into the center of the wet sheet, and surrounds this warm tone with cerulean blue. The strokes blur and blend on the wet painting surface.

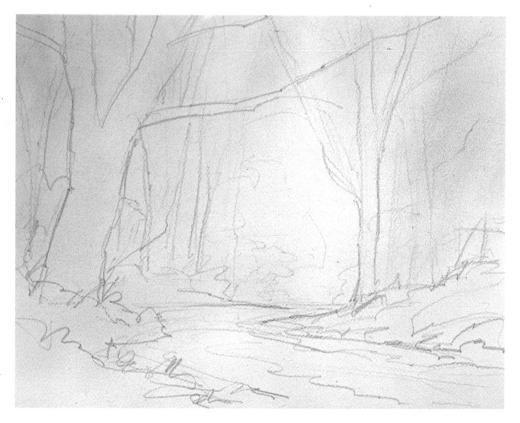

Step 2. While the paper is still wet, the artist mixes a slightly darker tone of cerulean blue and yellow ochre on his palette. He quickly brushes broad strokes of this mixture across the wet sheet to suggest the silhouettes of the pale, distant trees. Like the strokes of Step 1, these new strokes blur and blend as they strike the wet paper. However, the paper isn't quite as wet as it was before, so the new strokes don't disappear altogether, but retain a slightly more distinct shape. One important caution about the wet-into-wet technique: wet paper tends to dilute your colors, so make your strokes darker than you want them to be. They'll dry lighter.

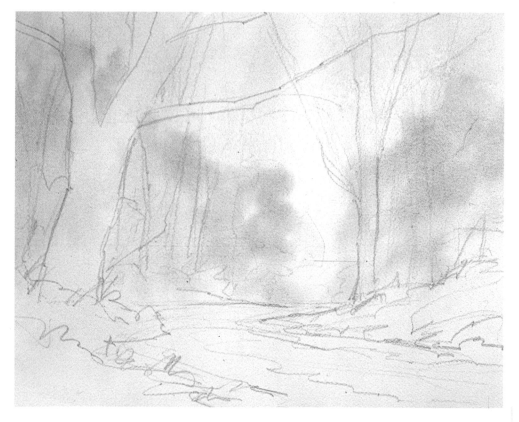

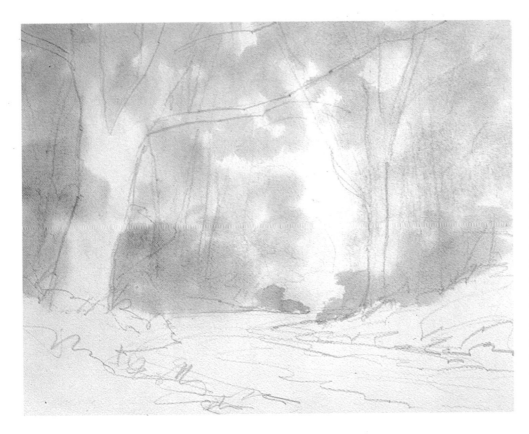

Step 3. The paper is drying rapidly, but the surface still hasn't lost its shine. The artist quickly adds broad strokes of foliage with cerulean blue and burnt umber. Warming the mixture with more burnt umber, he brushes darker strokes along the bases of the trees. The paper is dryer than it was in Steps 1 and 2, so the strokes are more distinct now, although there are still soft edges where the strokes melt into the damp, underlying color. By the end of this step, the paper has lost its shine. This means that it's still moist, but not wet enough to take strokes of fresh color without marring the mixtures that are already there.

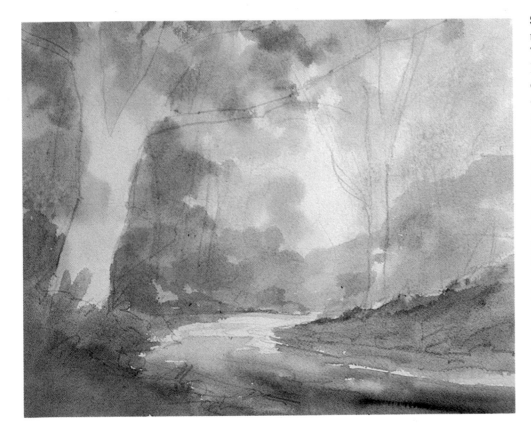

Step 4. The artist waits for the paper to dry thoroughly. Then he rewets it with a large, flat, soft-hair brush, carrying the clear water down to the edge of the road and the bases of the trees. Letting the water sink in and dry slightly so that his strokes won't be too blurred, he builds up the shadowy masses of foliage with darker mixtures of burnt umber, cerulean blue, and yellow ochre. He blocks in the warm tone in the lower left with burnt sienna and yellow ochre. Then he paints the rest of the foreground with strokes of burnt umber and ultramarine blue, allowing the strokes of the road to run softly into the wet tones of the grasses on both sides.

Step 5. When the entire painting is thoroughly dry, he paints the dark trunk and branches at the right with ultramarine blue, burnt umber, and a little new gamboge in the lighter area. Adding more water to this mixture, he indicates the more distant trunks and branches. Because they're painted on bone dry paper, these strokes are sharper and more distinct than the wet-into-wet mixtures of Steps 1 through 4. However, the dark tree at the left contains a wet-into-wet mixture of another kind: the artist has placed the light and dark strokes side-by-side and the wet colors run together.

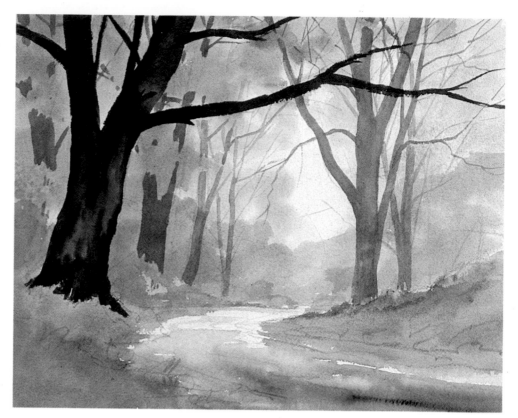

Step 6. Still working on the dry paper, the artist develops the tones and textures of the foreground. With a moist (not dripping wet) brush, he indicates the warm grasses and weeds in the lower left with cadmium orange, burnt sienna, and ultramarine blue. The rough texture of the paper breaks up the strokes. Lightening this same mixture with more water, he paints the opposite side of the road in the same way. Then he adds dark ruts to the road with strokes of burnt umber and ultramarine blue—some strokes have more water and some less—letting the wet strokes flow together and mix "accidentally."

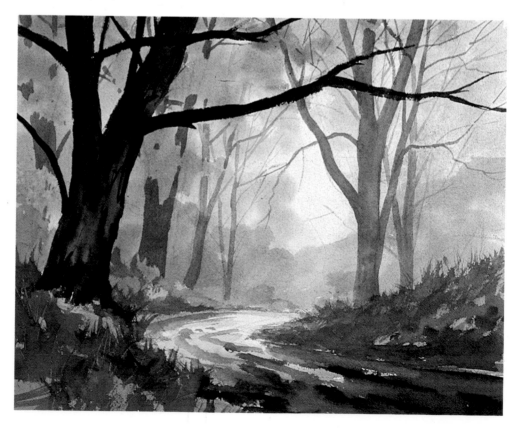

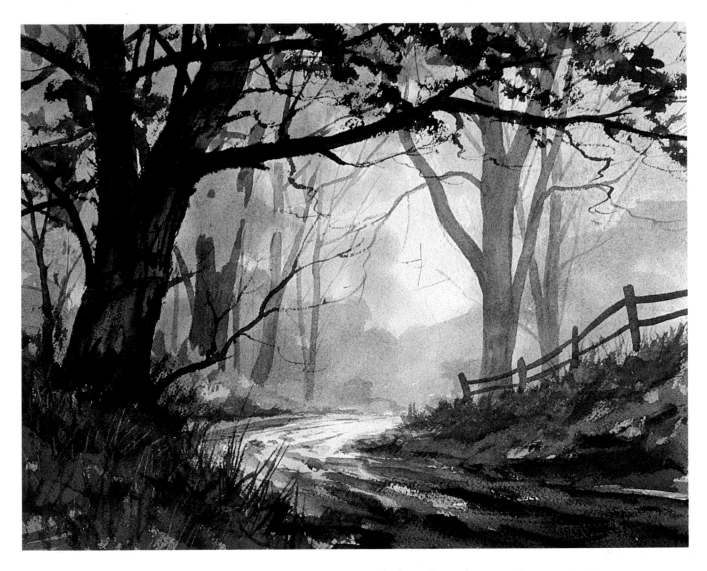

Step 7. When the foreground is thoroughly dry, the artist adds the details of the dark grass in the lower left with crisp strokes of ultramarine blue and burnt sienna. With the corner of a razor blade, he scratches out the pale blades of grass that catch the light. He darkens the opposite side of the road with drybrush strokes of burnt umber and ultramarine blue, and then adds more drybrush strokes to darken and accentuate the rough texture of the road itself. Moistening a round brush with a dark, fairly dry mixture of ultramarine blue and burnt sienna, the artist turns the brush on its side and drybrushes ragged strokes across the top of the picture to suggest clusters of foliage on the dark tree. Adding more water to make this mixture more fluid, he draws slender lines to indicate more twigs and branches. Then he uses this warm mixture to add small trees along the left-hand edge of the painting. The entire paper is covered with color now, except for the pale patch at the center of the road, which is spotlit by the light that comes through the overcast sky. Reviewing the sequence of steps in the execution of this painting, you'll recall that all the wet-into-wet mixing was done in Steps 1 through 4. By the end of Step 4, the painting was covered with large, soft masses of color. Over these blurred, wet-into-wet mixtures, the artist completed the picture with crisp, distinct strokes. It's rare for an artist to paint an *entire* picture wet-into-wet. Such a picture tends to have a vague, monotonous, fuzzy look. It's far more effective to combine wet-into-wet mixing— or the wet paper technique as it's sometimes called—with more distinct brushwork on dry paper, as you've seen in this demonstration.

Step 1. The Impressionist and Post-Impressionist painters of the late nineteenth century created vibrant optical mixtures. They built up their paintings with individual strokes, placed next to *and* over one another, to produce a mosaic of shimmering color. The *stroke technique*, as it might be called, is demonstrated here. The artist begins with a fairly precise pencil drawing so that he can plan the placement of his strokes accurately. Then he brushes a delicate tone of phthalocyanine blue, burnt umber, and yellow ochre across the sky, gradually adding more water and yellow ochre as he moves toward the horizon. Strokes of this mixture are carried into the water.

Step 2. The artist has chosen a sheet of smooth watercolor paper on which the strokes will be sharp and distinct. He begins to build up the warm tones of the trees with an underpainting of new gamboge, yellow ochre, and alizarin crimson, applied in bold, clearly defined strokes. By varying the proportions of the colors in the mixture, he makes some strokes brighter and others more subdued. Paler strokes of this mixture are carried down to the ground beneath the trees. And the low foliage on the far shore is indicated with strokes of ultramarine blue, warmed with a little burnt sienna and yellow ochre, diluted with lots of water.

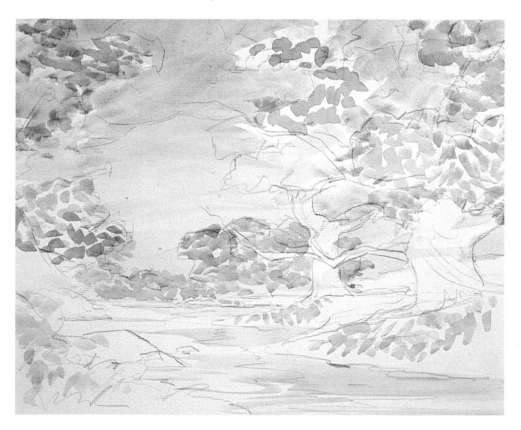

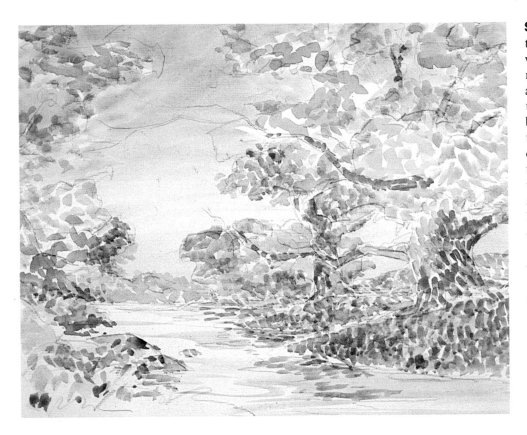

Step 3. The tree trunks on the right are underpainted with warm strokes of alizarin crimson, burnt sienna, and yellow ochre. This mixture reappears in the branches and the ground at the bases of the trees. The darker, cooler tones of the tree at the center of the picture are rendered with strokes of ultramarine blue, burnt umber, and yellow ochre—repeated in the water to suggest a reflection. The cool tones in the lower left and in the distant water are strokes of cerulean blue with a hint of burnt umber. The artist begins to add cool strokes to the grass and its reflection on the right with greenish tones of ultramarine blue and new gamboge.

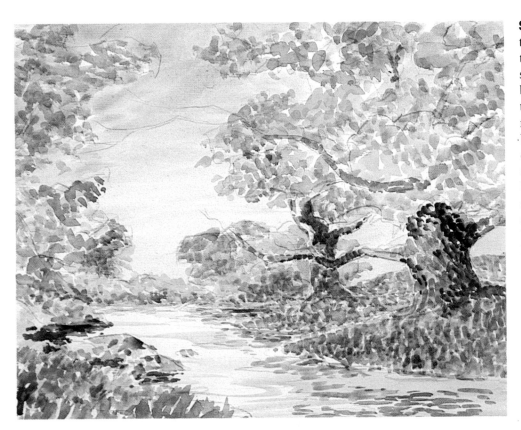

Step 4. The artist continues to darken the thick tree trunk at the right with strokes of alizarin crimson, burnt sienna, and a little ultramarine blue. He adds much more ultramarine blue to this mixture to darken the shadowy trunk at the center. With a brighter mixture of alizarin crimson, new gamboge, and a touch of burnt sienna, he builds up the color in the lower left foreground. He adds more water to this blend for the warm strokes that enrich the foliage of the trees and suggest the warm reflection in the water at the lower right.

Step 5. The shadows within the foliage are crisp strokes of ultramarine blue, warmed with a hint of alizarin crimson. To vary the density of the shadows, some strokes are made darker, while others are made paler with more water. Notice that the strokes are gradually becoming smaller. The artist has begun with his biggest, boldest strokes. Then, as he makes the forms of the landscape more distinct, he works with smaller brushes. It's also interesting to see how he leaves spaces between the strokes so that each new layer of brushstrokes allows the underlying colors (and white paper) to shine through.

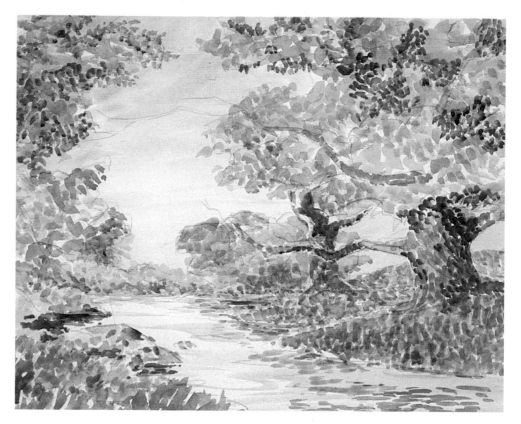

Step 6. The artist continues to enrich the shadows with darker, denser strokes of ultramarine blue and alizarin crimson. Now there are strong darks not only in the foliage, but on the shadow sides of the trunks and on the ground. The artist uses the same dark mixture to define the branches more precisely, adding more branches among the foliage, and building up a strong shadow beneath the low mass of trees on the far shore—and darkening its reflection in the water. He also begins to place small, distinct strokes of ultramarine blue over the warm undertone of the foliage. The two colors mix to create the cool colors of the leaves and shadows.

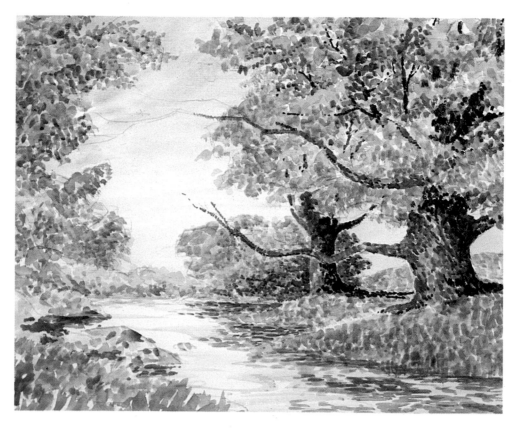

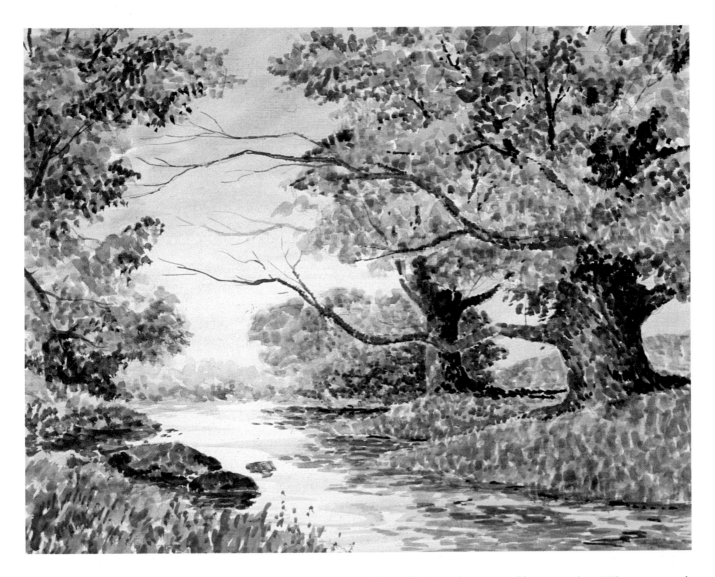

Step 7. Concentrating on the left side of the picture, the artist strengthens the darks among the foliage with small, precise touches of ultramarine blue and alizarin crimson. He also uses this mixture to strengthen the cool reflections of the trees in the water. The rocks at the lower left are darkened with strokes of new gamboge, alizarin crimson, and burnt sienna. The watery shadows beneath the rocks are accented with touches of ultramarine blue and alizarin crimson. Then the sunny grass in the lower left is strengthened with touches of alizarin crimson and cadmium orange, cooled with viridian. The artist adds more detail to the trees on the right, carrying several branches across the open sky with strokes of burnt sienna, alizarin crimson, and ultramarine blue. He adds more branches to the trees on the left with this mixture. Stronger darks are also added to the trees on the right with ultramarine blue, alizarin crimson, and burnt umber. When you work in the stroke technique, it's important to know when to stop—before you build up so many layers of strokes that the clear colors begin to turn muddy and indistinct. Since the artist feels that the colors are now as luminous as he can make them, he stops. There are several points to remember about the stroke technique. First, this intricate buildup of strokes looks particularly effective when it's combined with areas of smooth, unbroken color like the sky and water in this picture. Second, you must remember to let each layer of strokes dry thoroughly before you apply the next layer. Third, you build up your colors gradually, working with fairly pale and transparent tones until the very end, when you can pile up strong colors and rich darks.

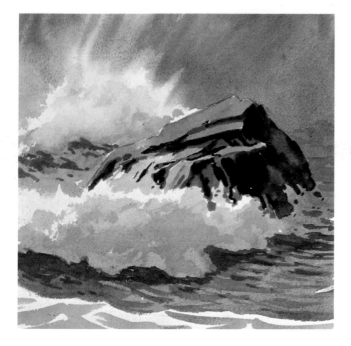

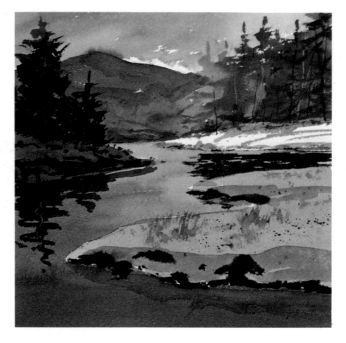

Warm and Cool. Contrast is always the most effective way to call the reader's attention to the focal point of your picture. Here, the viewer's eye goes directly to the warm, sunlit top of the rock because it's surrounded by the cool tones of the sky, foam, and water.

Bright and Subdued. Another way to direct the viewer's eye to your picture's center of interest is to plan a contrast of bright and subdued color. Here, the sunlit tone of the tree is surrounded by the subdued colors of the sky, mountain, and icy water.

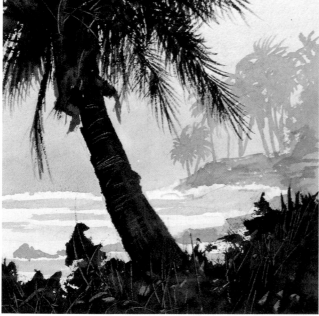

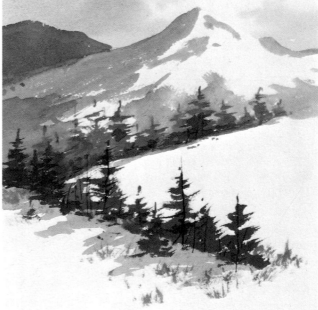

Light Against Dark. When you're working with subdued colors, a contrast of values is particularly effective. Here, the pale, windblown palms in the distance are framed by the dark shape of the palm and the grass in the foreground.

Leading the Eye. Color and value can be used to create a path for the eye to follow into the picture. The dark, warm line of trees, silhouetted against the snow, zigzags from the foreground into the middle distance, carrying the viewer's eye to the snowy peak of the mountain.

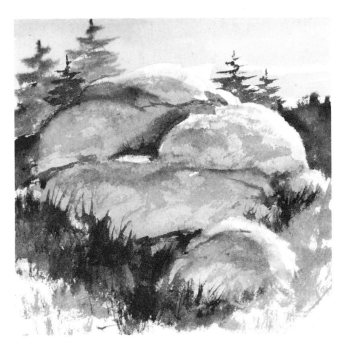

Cubical Form. To paint the forms of nature, you must learn about light. If you visualize this cliff as a couple of irregular cubical forms, you can divide these forms into lighted top planes, a left side plane that also receives the light, and big frontal planes that are in shadow. The shadow planes pick up reflected light from the water.

Rounded Form. Study the gradation of light and shade on the round rock in the lower right. First there's the *light*, which is bare paper. Then there's a pale *halftone*, falling between the light and shadow. As the rock turns away from the light, there are dark strokes for the *shadow*. Then, toward the bottom of the shadow there's a lighter tone called the *reflected light*.

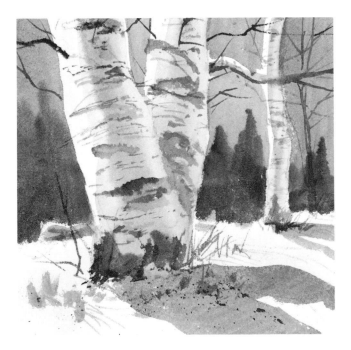

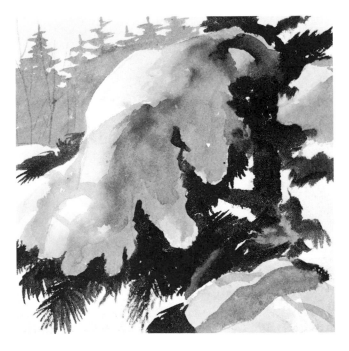

Cylindrical Form. Running your eye over the cylindrical trunk from left to right, you can see the light (bare paper), the halftone between the light and shadow, the shadow itself, the reflected light at the edge of the shadow, and the darker cast shadow on the ground. The light comes from the sun, while the reflected light bounces off the snow, which acts like a mirror.

Irregular Form. This irregular clump of snow on a branch shows the same gradation of light and shade. Looking from top to bottom, you see the light (represented by the bare paper), the pale wash of the halftone, the darker strokes of the shadow, and finally the paler tones of the reflected light within the shadow.

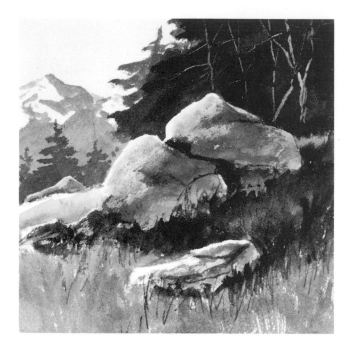

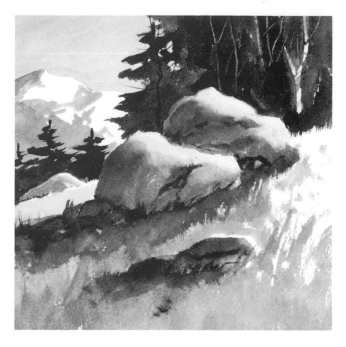

Side Lighting from Left. The light hits the rocks from the upper left, so those four familiar tones move from left to right. The artist has left bare paper for the lights, indicated the halftones with pale washes (scraped lightly with a razor blade), drybrushed the shadows, and scraped in the reflected lights.

Side Lighting from Right. Now the light comes from the right, so the sequence of four tones is reversed. The artist has painted light, halftone, shadow, and reflected light wet-into-wet, so they flow together. He's used a cleansing tissue to lift wet color from the lights, and blotted away some reflected lights.

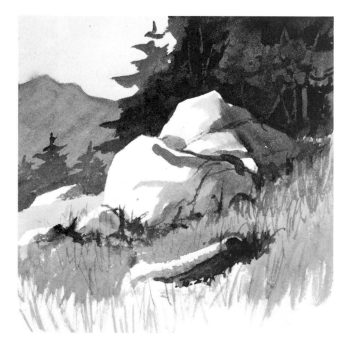

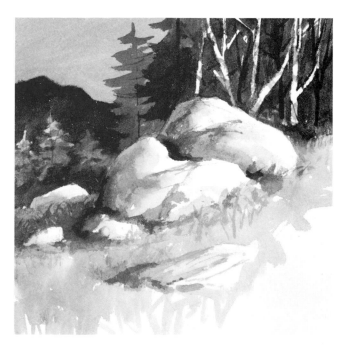

Three-Quarter Lighting from Left. When the light comes over your left shoulder, the lighted planes are bigger and there's less shadow. The halftones are painted first and allowed to dry, then the shadows are added. The artist lightens his last few shadow strokes with water to suggest reflected light.

Three-Quarter Lighting from Right. The sequence of tones is reversed again when the light comes from above your right shoulder. The lighted planes are bare paper. The artist covers the rest of the rock with a pale halftone. He brushes in the shadows while the halftone is wet. He reinforces the shadows when those tones are dry.

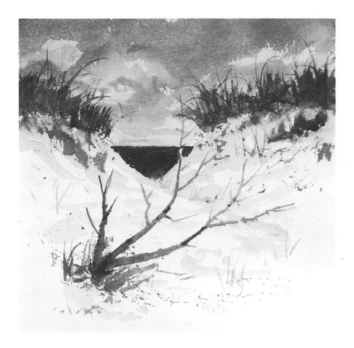

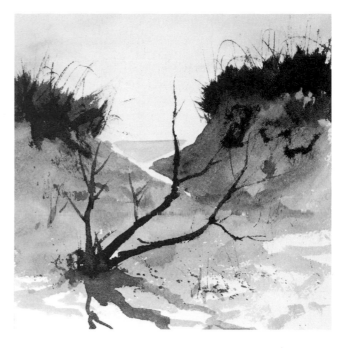

Front Lighting. In this monochrome watercolor study, the sun is above and behind your head, striking the front of the dunes. Thus, the dunes are almost completely bathed in bright light, with just a few halftones and no shadows, except for the cast shadows beneath the grass and under the branches in the foreground.

Back Lighting. Now the sun has moved behind the dunes, which become dark silhouettes against the pale sky. Just the edges of the dunes catch the bright sunlight. There's no halftone between the light and shadow. Each dune is almost entirely in shadow, but these shadows are filled with reflected light that's picked up from the sky, and perhaps from nearby tide pools.

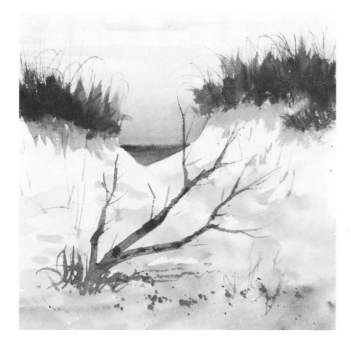

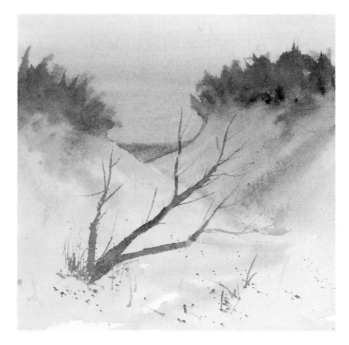

Top Lighting. When the sun is overhead, the upper parts of the dunes catch the light and the lower areas are in shadow. The artist starts with darker strokes at the bottom of the picture, adding more water as he works upward, and leaving the paper bare for the sunny areas. The sun is directly above the patches of beach grass, so there are strong cast shadows beneath them.

Diffused Light. On a hazy or overcast day, the light is blurred, so there's no predictable sequence of light, halftone, shadow, and reflected light. Since there's also not much distinction between them, you must study your subject and paint what you see. Here, the artist paints the indistinct tones on wet paper, letting one tone blur softly into another.

Sunny Day. Just as the landscape is transformed by the changing position of the sun in the sky, so your subject will also be transformed by the weather. As you see in this sketch, on a sunny day, there are strong contrasts of light and shadow—like the contrast between the shadowy slope at the right and the sunny slope in the middle of the picture, or between the light and shadow planes of the rocks in the foreground. The strong light creates sharply defined shadows that cross the landscape, like those in the grass at the lower edge of the picture. There may be clouds in the sky (which may also cast shadows on the land), but there are plenty of spaces between the clouds for the sun to shine through.

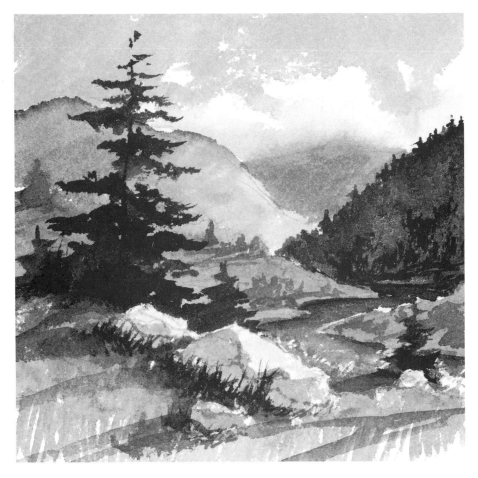

Cloudy Day. When clouds cover the sky and block most of the sun's rays, a lot of the landscape tends to be in shadow. There are also fewer strong contrasts between light and shadow. However, there's often a break in the clouds, allowing a few rays to come through and spotlight some part of the landscape—like the sunlit slope at the right and the bright edge of the shore in the center of the picture. It's interesting to see that the artist has painted this dark sky wet-into-wet, while he's painted the sunny sky—in the previous picture with distinct washes.

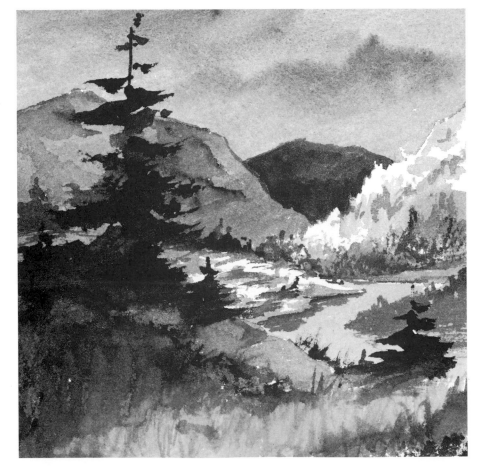

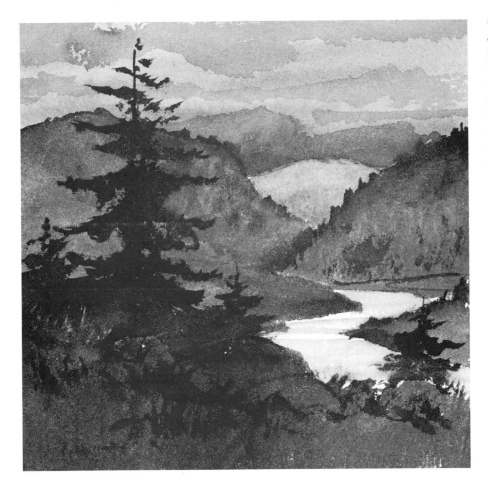

Overcast Day. When the sky is completely covered by a cloud layer, the entire landscape tends to be overcast with a shadowy tone that minimizes contrasts. In this study of the same landscape on an overcast day, most of the shapes are dim silhouettes with virtually no indication of light, halftone, shadow, or reflected light. A shiny surface like the water seems brighter than the rest of the landscape because the mirror-like surface bounces back whatever light is available. On each shadowy slope, the artist lets the various tones melt into one another, wet-into-wet. In the same way, the dark silhouette of the evergreen at the left fuses softly into the wet tone of the dark slope in the foreground.

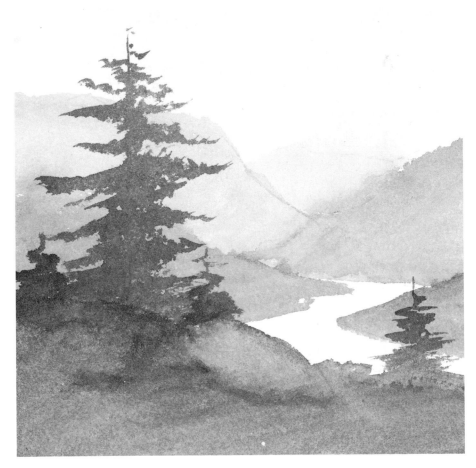

Hazy Day. When a thin haze veils the sun, more light is apt to come through. But that light is soft and diffused, so the landscape tends to be simplified to pale silhouettes. The artist works mainly with flat, delicate washes, letting one wet wash run into another in the distant mountains. Once again, the dark evergreen is a silhouette that fuses with the wet tone of the slope in the foreground. The shiny surface of the stream reflects the soft light and is again the brightest note in the picture. To learn about values in different kinds of weather, it's worthwhile to spend time making monochrome watercolor sketches outdoors.

High Key. Before you touch your brush to the watercolor paper, it's important to examine your subject carefully and decide whether that subject has a definite *key*. If most of the tones are fairly pale—coming from the upper part of the value scale—you're going to paint a high-key picture. In a high-key subject like this coastal landscape, not only the lights, but the half-tones, shadows, reflected lights, and cast shadows will be quite pale. To create a high-key effect, the artist has left a lot of bare paper and has added a great deal of water to nearly all of his washes. The only strong darks are in the foreground.

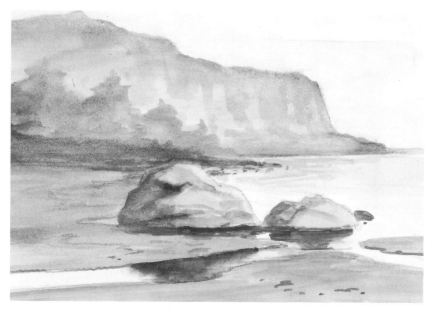

Middle Key. With a change in the light and weather, the same landscape may be transformed to a middle-key subject. Although there are strong darks in the foreground and a few bright lights in the sky, most of the tones come from the middle part of the value scale. There are also more tonal contrasts in this middle-key landscape than there are in the high-key landscape above. In general, you'll find that most subjects are in the middle key.

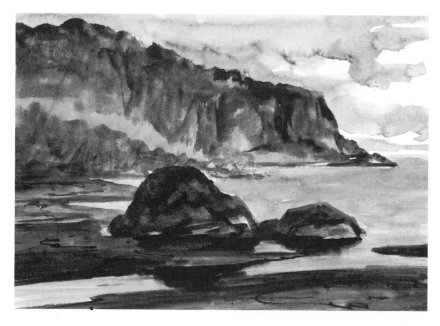

Low Key. As the light begins to fade toward the end of the day, this same landscape becomes a low-key subject. That is, most of the tones come from the lower part of the value scale, although there are a few bright lights in the sky and on the edge of one rock in the foreground. Not all subjects fall neatly into one of these three categories—high, middle, or low key—but if you *can* identify a specific key, this will help you plan your values more accurately and you'll capture the mood with greater sensitivity.

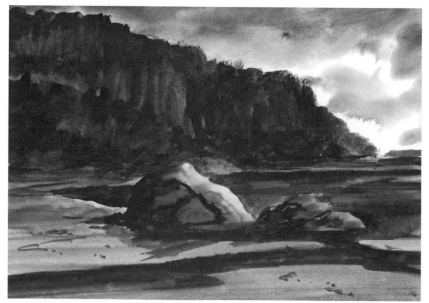

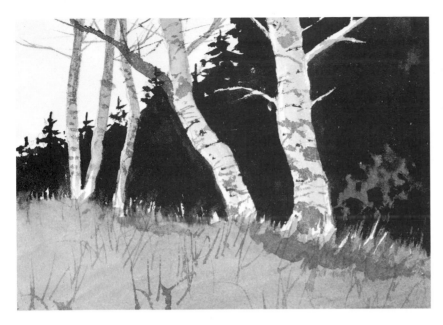

High Contrast. As you plan a watercolor, it's also important to determine the *contrast range* of your subject. If the tones come from all over the value scale—from the palest values to the darkest ones—then you've got a high-contrast picture. In this monochrome watercolor sketch, there's the bright tone of the sky, the dark tone of the woods, and the middletones of the trees and grass. You can't really identify a specific key in this picture, but you *can* determine the contrast range before you start to paint.

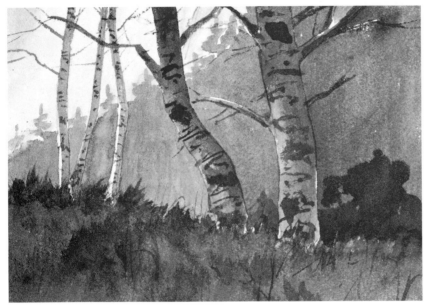

Medium Contrast. As the light fades or becomes diffused by a cloudy sky, the pattern of light and shade changes. This same landscape becomes a medium-contrast subject. Now the tones fall closer together on the value scale. They don't come from the extremes of the scale as they do in a high-contrast subject. Instead, the lights become a bit darker, while the darks become somewhat paler. This particular watercolor study happens to be in the *middle key*, as well as the *medium contrast* range. But that's not always true. A *high-* or *low-key* subject can also be in the medium contrast range if there's reasonable contrast in a few areas—which is true of all the studies on the opposite page.

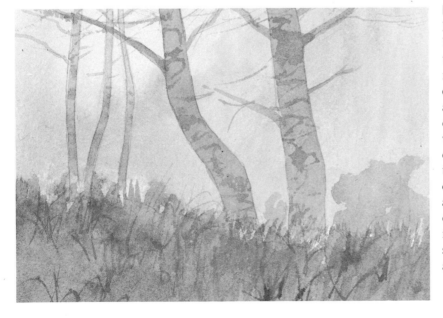

Low Contrast. On a misty day, this pale landscape becomes a low-contrast subject because there's very little distinction between light, halftone, and shadow. But remember that mist isn't the only thing that creates a low-contrast subject. This would also be a low-contrast painting if a rainy day darkened the landscape so that all the values came from the middle of the scale, or if nightfall darkened the landscape so that all the values came from the lower end of the scale. To record these changes in key and contrast, choose some familiar outdoor subject that's close to home, and make a series of monochrome watercolor sketches under different conditions of light and weather.

Step 1. To demonstrate how to paint a high-key subject, the artist chooses a sunny desert landscape in which all the colors appear to be "bleached" by the brilliant light. He brushes clear water over the sky and then brushes pale strokes onto the wet surface, where they soften and blur. When the sky is dry, he blocks in the shadow planes of the distant mountains with strokes that are approximately the same value as the soft clouds. By the end of Step 1, he has established two of his major values: the lightest value, represented by the bare paper, and a pale middletone that appears both in the sky and in the shadow planes of the mountains.

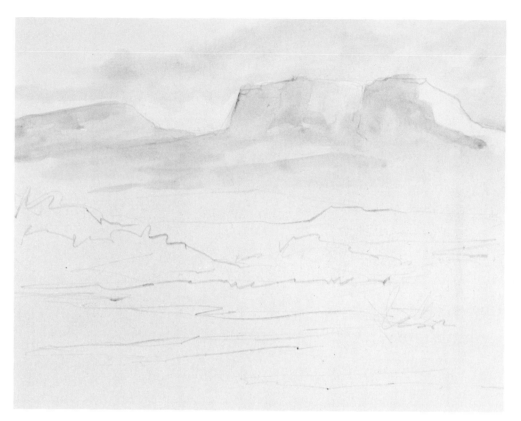

Step 2. Moving into the middleground, the artist blocks in the shadowy face of the low ridge with a darker middletone. Actually, he paints this with strokes that vary in value, but they blend, wet-into-wet. In the immediate foreground, the artist paints the delicate tone of the water with the same pale middletone that appears in the sky; but at the edge of the water, he introduces a strong, dark shadow, which blurs softly into the wet tone of the water. Now, at the end of Step 2, the picture contains a relatively strong dark, two middletones, and the light tone of the bare paper.

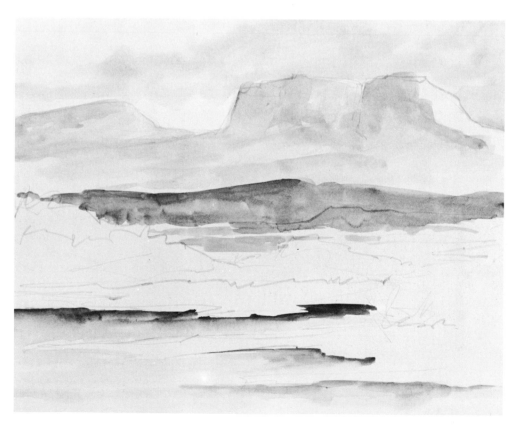

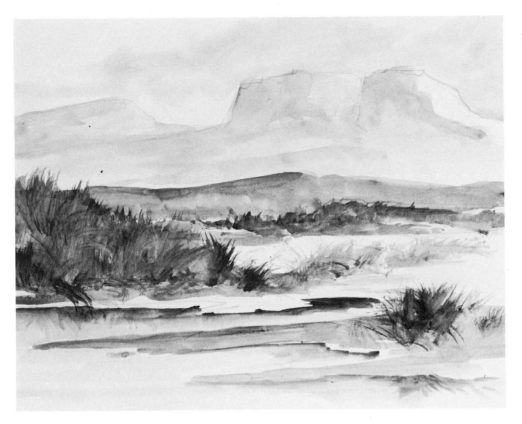

Step 3. With scrubby, erratic strokes that jut in various directions, the artist indicates the clumps of desert plants with a mixture that's approximately the same value as the dark shadow at the edge of the water. He indicates the slender, horizontal strip of sand that moves out into the water in the foreground with a dark middletone—similar to that of the shadowy middleground ridge. Although most of the tones in the landscape are pale, the artist remembers the "laws" of aerial perspective: the darkest tones and the strongest contrasts are in the foreground, while things grow paler, with less contrast, in the distance.

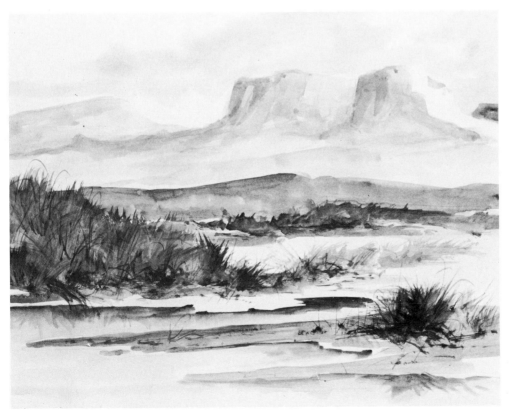

Step 4. The artist completes this high-key landscape by introducing a few touches of the darker middletone on the shadowy crags of the distant mountains, and on the slope at the foot of the mountain to the left. He reinforces the tropical plants and foreground shapes with slightly darker touches. Although there *are* a few strong darks, most of the tones come from the upper part of the value scale—and this is mainly a high-key subject. Try painting a subject like this first in monochrome—on a small scale—and then paint it again in color when the values are fixed firmly in your mind.

Step 1. The artist brushes the upper part of the picture with clear water, and then he adds strokes that represent two middletones—one light and one dark. He blots away the clouds with a crumpled cleansing tissue, exposing the white paper to establish the lightest value in the picture. While the paper is still slightly damp, he blocks in the mountain, which is similar to the dark middletone that appears at the center of the sky. Notice how he adds more water to his strokes to suggest that the lower slopes of the mountain fade away into a pale mist. By the end of Step 1, you can already see the lightest value in the picture and the two middletones.

Step 2. At the left, the artist paints the silhouettes of the evergreens and their shadows with the darker middletone that already appears in the mountain and the center of the sky. The shadowy land at the edge of the frozen stream in the lower left is painted with a faintly darker version of this same middletone. Finally, to establish the darkest value in the picture, the artist paints the nearby evergreens with dense tones, with just enough water to make the color flow smoothly. While the color is still damp, he uses the point of his wooden brush handle to scratch away the light trunks.

Step 3. As the artist paints the shadowy side planes with a dark value that's similar to that of the trees, the mountain becomes more solid and three-dimensional. Notice how he leaves gaps between the dark strokes to expose the middletone that he's painted in Step 1. He darkens the evergreens at the left—and suggests another clump of evergreens in the lower left-hand corner with dark strokes. Halfway down the mountain, the artist adds the misty outline of a lower ridge.

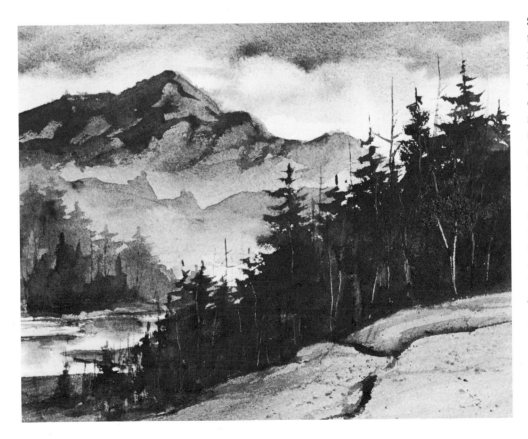

Step 4. The artist finishes the landscape by adding more dark evergreens on both sides of the stream in the lower left. He also adds dark cracks in the rocky slope at the lower right and drybrushes some texture over the rocky surface. He scratches in more trunks and branches among the dark evergreens. Although there *are* some strong darks and one strong light among the clouds, most of the tones come from the central area of the value scale, so this is *predominantly* a middle-key picture. However, because of the strong darks and lights, it's also a high-contrast subject.

Step 1. To paint a high-contrast picture, it's a good idea to define your lights and shadows very clearly so that the tonal contrasts are as distinct as possible. Thus, the artist begins with a pencil drawing that's simple, but *precise*. His lines define the exact contours and angles of the trees. He also traces the contours of the snowbank with exact pencil lines. If he was dealing with the vague tones of a foggy, low-contrast landscape, he might have done a looser drawing—but high contrast means sharp definition of forms and values.

Step 2. Brushing clear water across the top half of the picture, the artist wets the paper down to the lines that define the tops of the snowbanks. As the water sinks in and the paper begins to dry, he adds the soft tone of the distant hill just before the wet paper loses its shine. The strokes melt softly into the wet surface, but the paper is just dry enough for the hill to retain a distinct shape. (One important tip about using the wet paper technique: if a form begins to blur beyond recognition, you can sharpen the edges by blotting around the contours with a paper towel or a cleansing tissue.)

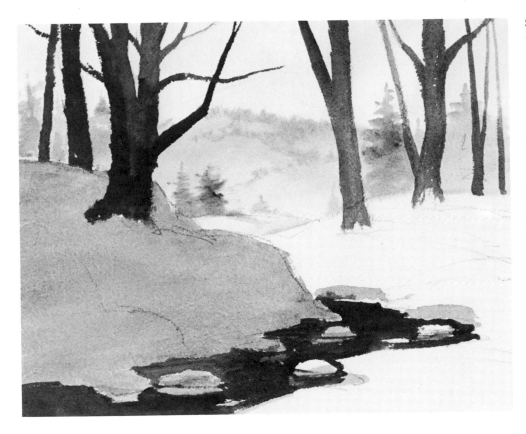

Step 3. The artist blocks in the shadowy snowbank in the left foreground with a darker tone than the distant hill. He suggests the foliage at the top of the hill, plus some distant evergreens, with the same tone as the shadowy snowbank—adding a few dark touches to the evergreens. When these tones are dry, he paints the dark trees and the jagged stream with strong, dark strokes, leaving gaps in the stream for the rocks—to which he adds touches of shadow. Notice how the distant trees at the right are slightly paler than the nearer trees at the left, which are also in shadow. By the end of Step 3, all the major values have been established.

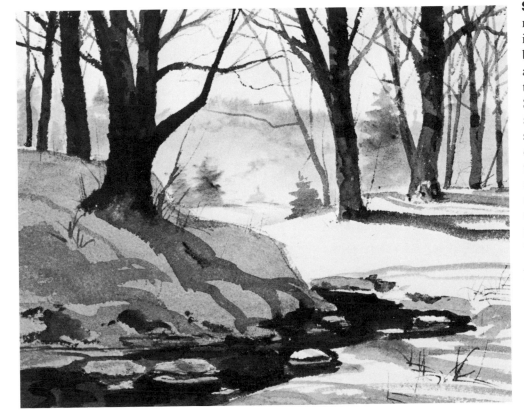

Step 4. The big trees at the right are darkened. The artist adds more trees and branches in the upper right, and a few more branches to the trees in the upper left. Strong, distinct lines of shadow are swept across the sunny snow at the right and down the shadowy snow on the left. More shadow lines are added in the lower right, and a few blades of grass complete the picture. The finished landscape is obviously a high-contrast subject: the lights and darks come from the two extremes of the value scale, while the halftones fall between these two extremes. The contrast is heightened by the hard-edged, distinct character of the brushwork.

Step 1. Most watercolors are in the medium-contrast range, which means that the lightest tones fall just below the top of the value scale, while the darks stop just above the lower end of the scale. In this medium-contrast demonstration, the artist decides not to render the complex detail of this· wooded landscape branch by branch in the preliminary pencil drawing. Instead he indicates the main shapes with casual lines. He locates the tree trunks, the near and far edges of the lake, the evergreens on the distant shore, and the overall shapes of the leafy masses. That's enough to guide him when he applies loose, fluid washes.

Step 2. The artist begins with the pale middletone of the sky, letting the wash run down the smooth paper to create an "accidental" streaky texture. Although the sky will later disappear behind the foliage, the irregular brushwork will lend vitality to the strokes that go over the sky. Just above the horizon, he lightens the wet sky with a crumpled cleansing tissue and adds a low, distant hill in the same value. He blocks in a dark middletone to indicate the evergreen on the far shore, and then he repeats the paler middletone of the sky in the water, adding a strip of shadow along the shoreline. He begins to cover the tree trunks with the two middletones.

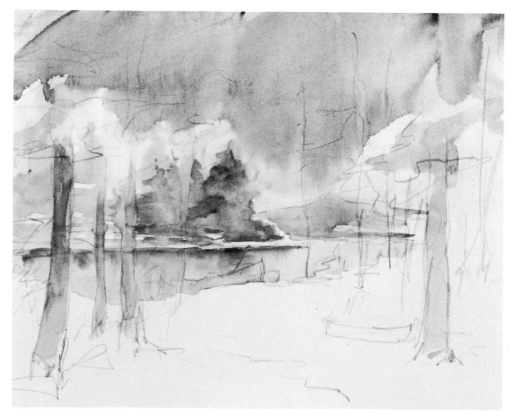

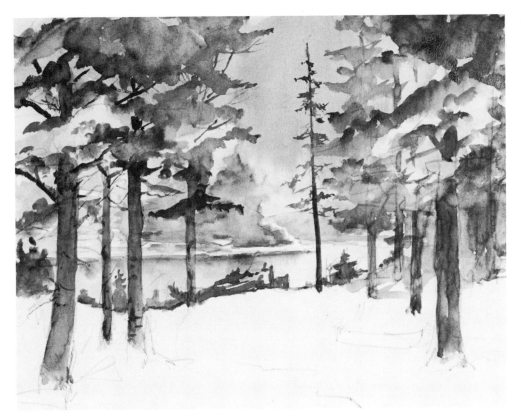

Step 3. Working mainly with the darker middletone, he begins to add some of the strong darks. He lets the brush wander over the foliage, depositing free, fluid strokes that are mainly the darker middletone, with an occasional strong dark. Then he darkens the tree trunks, adds a few evergreens along the near shore with approximately the same value, and indicates the fallen tree trunk along the shore in the center of the picture. This particular kind of brushstroke is typical of a watercolor painted on smooth paper. The stroke is fluid, yet has a sharp edge.

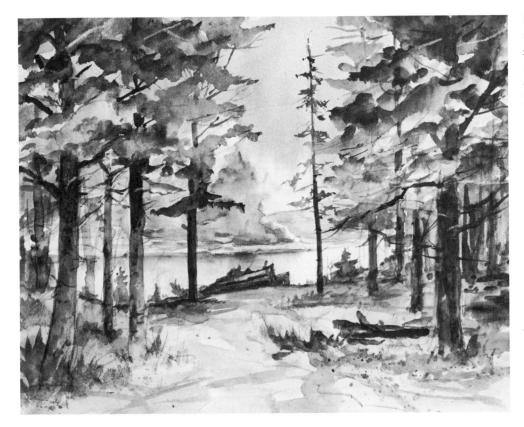

Step 4. With the same casual, wandering brushstrokes, the artist adds darks among the foliage to indicate shadows within the leafy masses. He continues to darken the trunks, adding more branches. Finally, middletones and a few darks appear on the ground to suggest shadows, grasses, and other details around the bases of the trees. The artist has worked gradually from light to dark, covering most of the painting with middletones, eliminating the white paper almost completely, and stopping after he adds just a few strong darks. The finished picture is in the medium-contrast range. It's also in a middle key.

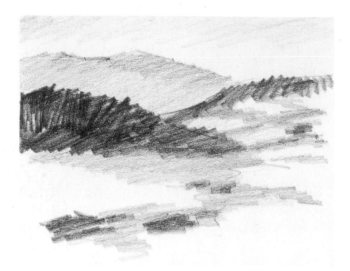

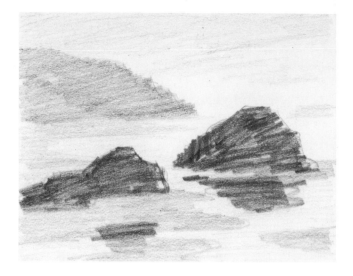

Sketch for Demonstration 1. Watercolor dries so quickly—and *everything* happens so quickly—that you've got to do a lot of advance planning. Therefore, many watercolorists do little value sketches in pencil or chalk before they start to paint. The value sketch can just be a scribble, like this tonal plan for Demonstration 1. The artist locates his strongest darks on the slope at the left, on the top of the slope at the right, and in the foreground rocks. He places the middletones on the distant hill and in the zigzag shape of the dark field that breaks through the snow in the foreground.

Sketch for Demonstration 6. This small tonal plan took no more than a couple of minutes, but it gave the artist a clear idea of the location of his darks, lights, and middletones. The strongest darks appear in the rocks and in their reflections. The distant headland represents the darker middletone. The lights and the paler middletones are in the sky and water. When you look back at the finished painting, you'll see that the artist changed his mind about a few things. But these changes were easier to make because he started out with a clear-cut value plan.

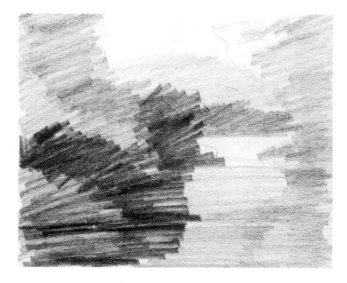

Sketch for Demonstration 7. At first glance, the tonal sketch for Demonstration 7 looks so scribbly that you can't recognize anything. But when you compare it with the finished painting, the sketch turns out to be surprisingly accurate in its rough way. Such a sketch doesn't have to look pretty—and it doesn't matter if no one understands the sketch but you. If it visualizes the main values accurately and fixes them firmly in your *mind*, it's a good tonal plan.

Sketch for Demonstration 9. The painting was executed in a rather limited, subdued color scheme. Thus, the power of the pictorial design depended less on color than on precise control of tonal contrasts. For this reason, the tonal sketch for Demonstration 9 is more precise than the usual scribbles. Actually, the artist made a *series* of two-minute value sketches, selecting the one you see here because it gave him the most accurate image of the dark foreground shapes, the lighted middleground road, the dim shapes in the distance, and the luminous sky.